IMAGES
of America

PITTSBURGH'S
POINT BREEZE

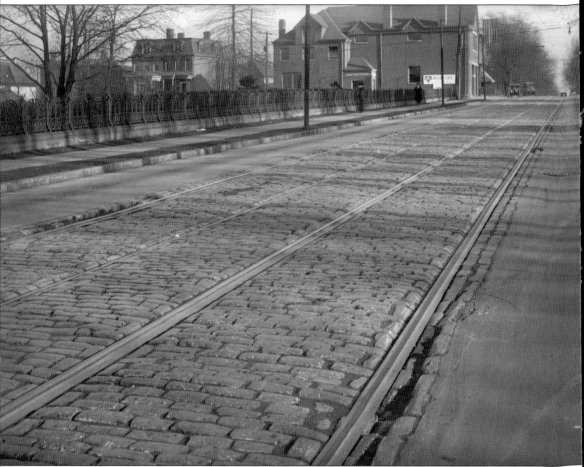

One of only two public buildings in Point Breeze, Engine House No. 16 has stood at the corner of Penn Avenue and North Lang Street for over a century. A billboard advertising the war fund is seen on the side of the firehouse in this photograph taken during World War I. The ornate fence of Henry John "H.J." Heinz's estate, Greenlawn, which still exists today, is seen on the left. (Courtesy of Archive Service Center, University Library Services, University of Pittsburgh.)

ON THE COVER: During the creation of Frick Park, it was determined that the park would be an ideal location for some kind of recreational activity that would enhance and beautify the landscape, as well as the surrounding neighborhood. After dedicated research, lawn bowling became a staple in Frick Park. The Frick Park Lawn Bowling Club is the only public organization of its kind in the commonwealth of Pennsylvania. (Courtesy of H.J. "Hank" Luba and the Frick Park Lawn Bowling Club.)

IMAGES
of America

PITTSBURGH'S
POINT BREEZE

Sarah L. Law
Foreword by Mayor Bill Peduto

ARCADIA
PUBLISHING

Published by Arcadia Publishing
Charleston, South Carolina

Printed in the United States of America

Library of Congress Control Number: 2014932586

For all general information, please contact Arcadia Publishing:
Telephone 843-853-2070
Fax 843-853-0044
E-mail sales@arcadiapublishing.com
For customer service and orders:
Toll-Free 1-888-313-2665

Visit us on the Internet at www.arcadiapublishing.com

To all Point Breeze families—past, present, and future

CONTENTS

FOREWORD

Although I represented seven neighborhoods in city council, there is only one that I call home—Point Breeze. Like so many of my neighbors, I was drawn to this one in particular because of its unique combination of stately homes, incredible parks, and small neighborhood business districts. Point Breeze is a hidden gem—even within the East End community. Although it has a historic past, from the earliest days when George Washington surveyed the land to create Penn Avenue, many people still do not know where it is. And even though many famous Pittsburghers like Andrew Mellon, Henry Clay Frick, Fred Rogers, Dick Thornburg, Willie Stargell, and so many more have made this their home, its critical role in our city's history is sometimes lost. Maybe that is what makes Point Breeze different. It is a neighborhood that enjoys its anonymity as much as it appreciates its history. I hope this book will be able to share the pride so many of us Breezers have in this beautiful, accepting, and ever-changing neighborhood. And I know that when you take the time to read it, you too will understand what an incredible treasure can be found in this neighborhood—Mr. Rogers' Neighborhood!

—The Honorable William Peduto
Mayor of Pittsburgh
City of Pittsburgh

ACKNOWLEDGMENTS

This book would not be complete without an important group of people. A special thanks goes to the following people: Rachel Rohbaurgh and Dr. Elisabeth Roark, Chatham University; Miriam Meislik, University of Pittsburgh Archives Services Center; Albert M. Tannier, Pittsburgh History and Landmarks Foundation; Martin Artaud, Carnegie Mellon University; Matthew Strauss, Heinz History Center; council member Daniel Gilman and Mayor Bill Peduto; Amy Fields and Annie Dillard and their families; Bill Grisom of North Point Breeze; the irrepressible Albert French; Christian Lebiere and Theresa Colecchio; ardent North Point Breeze supporters Marlene Demarest and her late husband, Prof. David Demarest; Ron and Bob Fuchs; Cheryl Hall, North Point Breeze Planning and Development Corporation; Point Breeze Organization; Joel Tarr, Carnegie Mellon University; school principal Sarah L. Sumpter, Pittsburgh Sterrett Classical Academy; Pittsburgh Linden K–5 School; and the late H.J. "Hank" Luba and the Frick Park Lawn Bowling Club.

A special mention of thanks goes to the Arcadia Publishing staff. To my family, love and thanks for your unfailing support. The images in this volume appear courtesy of the following:

Annie Dillard family (ADF)
Archive Service Center, University Library System, University of Pittsburgh (ASC)
Arthur G. Smith Collection, Chatham University (AGS)
Carnegie magazine, Carnegie Museum of Art (CMA)
Detre Library and Archives, Sen. John Heinz History Center (HHC)
H.J. Luba and the Frick Park Lawn Bowling Club (FPLBC)
North Point Breeze Planning and Development Corporation (NPBPDC)
Prof. David Demarest and his wife, Marlene Demarest (DMD)
Ronald and Robert Fuchs families (FF)
Sarah L. Law (SLL)

INTRODUCTION

In 1758, Gen. John Forbes led his English troops to dislodge the French from Fort Duquesne, following an old Indian trail that passed right through Point Breeze. Point Breeze was officially settled in 1758.

Pittsburgh's Point Breeze neighborhood was named after a famous early 19th-century tavern, the Point Breeze Hotel, owned by Thomas McKeown. It was located at the crossroads of a country lane (Fifth Avenue) and the Greensburg Turnpike (Penn Avenue). A natural intersection, the two roads brought countless travelers from (now downtown) Pittsburgh and beyond to enjoy dining at the hotel or to stay overnight.

As Pittsburgh grew, so did Point Breeze. Its bucolic flavor gave way to railroad expansion as the Pennsylvania Railroad's main line was constructed through the area, with factories growing along the railroad lines and stockyards growing west of Fifth Avenue and Penn Avenue.

The first migration to Point Breeze occurred in the first half of the 19th century. James Kelly, the Biddle family, and John Murtland were some of the first landowners in present-day North Point Breeze and Wilkinsburg. By the second half of the century, the city of Pittsburgh was expanding, and Point Breeze was a prime location for residences.

Point Breeze became a sought-after neighborhood for its clean air in industrial Pittsburgh. The neighborhood's flat topography and prime location along the railroads also helped develop the neighborhood. Point Breeze boasted not one, but two railroad stations—providing local residents railroad transportation to anywhere in the continental United States. Railroads were the fastest mode of transportation, the equivalent of today's airlines.

By the end of the 19th century, Pittsburgh rivaled New York City for the most millionaires per capita. They lived primarily in the eastern suburbs of Shadyside, East Liberty and Homewood in large, palatial mansions set in the spacious grounds that lined Fifth, Penn, Ellsworth, and other avenues. At one time, there were probably more than 100 such houses in the eastern suburbs, testifying to the great wealth concentrated in relatively few hands, which was a consequence of Pittsburgh's industrial development.

Burgeoning real estate entrepreneurs like the Mellon brothers took advantage of the growing and changing real estate market. In 1885, the area known as the Boulevard Park Plan was laid out. Only one house from the Boulevard Park Plan, on the corner of Thomas Boulevard and North Dallas Avenue, exists today.

Adjacent to the Boulevard Park Plan was the original Westinghouse Park Plan. Six houses were built before the developer went bankrupt. Of the six houses constructed, five remain in the 6900 block of Thomas Street.

Adapting to changing lifestyles and housing needs, many apartment buildings were constructed in Point Breeze. As the fortunes of many wealthy families grew, it was imperative that they had to move to New York to continue to amass their fortunes as well as their social standings. Many palatial mansions were abandoned, and estates eventually were divided into smaller lots. Smaller homes were built, and the Point Breeze real estate market boomed again—this time accommodating more, smaller families.

Researching this book always transports me to another time, another Pittsburgh. I was spurred on in my research when the niece of a family friend remarked, "Why did they build Clayton around all those small homes?" This book is dedicated to all Point Breeze families—past, present, and future.

One

THE GREAT ROAD
TO THE WEST

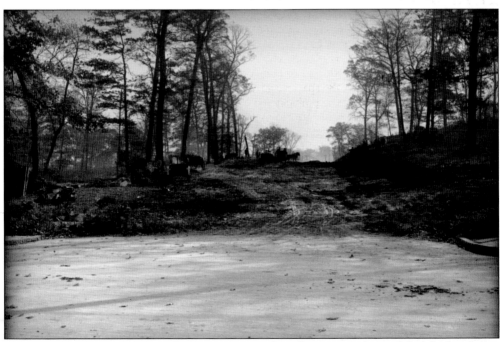

Taken during the creation of Willard Street at South Dallas Avenue (several decades later), this image illustrates how rural the Point Breeze neighborhood was before it became a sought-after residential neighborhood. Point Breeze was mostly forestland, with the old Indian trail nearby that was eventually to become present-day Penn Avenue. (ASC.)

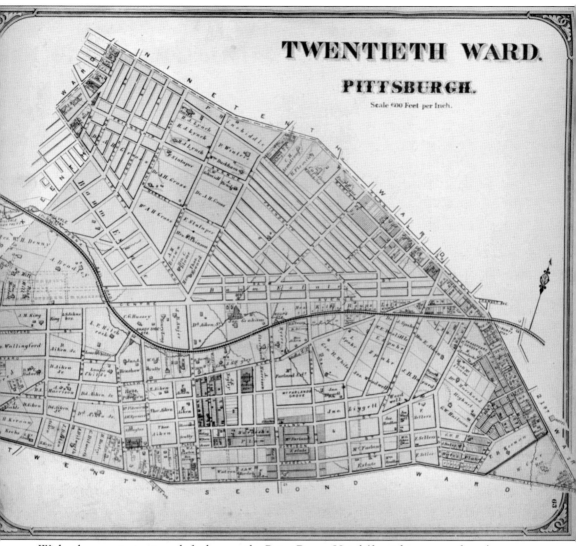

TWENTIETH WARD.

PITTSBURGH.

Scale 600 Feet per Inch.

With a large watering trough for horses, the Point Breeze Hotel (far right corner of map) sat on a natural intersection of the Greensburg Pike (now Penn Avenue) and the Fourth Street continuation from downtown Pittsburgh (now Fifth Avenue). The first proprietor, Thomas McKeown, built the establishment sometime after 1800. In his 1901 autobiography, *Life and Reminiscences*, William G. Johnston leaves the following account of the tavern: "In the following summer [1839], I spent about two months at the Point Breeze tavern kept by a Mrs. Parker. The suppers served were . . . truly delicious. Even yet I recall the frogs so daintily cooked and the savory smell which filled the long low dining room where a table groaning with every sort of delicacy was surrounded by guests . . . I usually spent the afternoons watching the gentlemen play at tenpins; I knew them all and all knew me." In the early 1830s, one could ride out from the city by "the Pike" (Penn Avenue) and return by the Fourth Street Road (Fifth Avenue), stopping midday at the hotel for lunch and a rest. (ASC.)

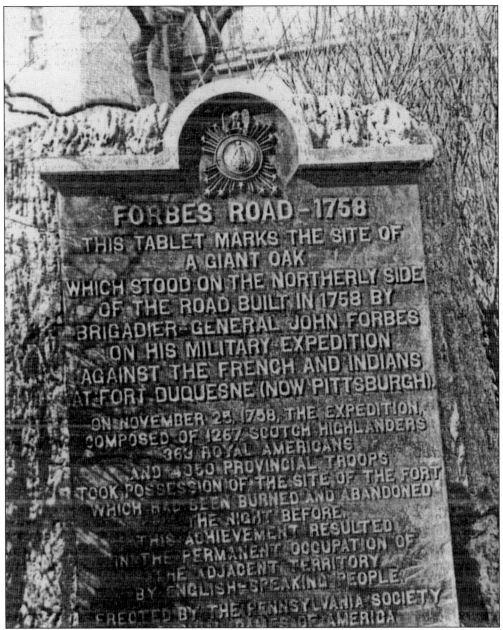

Placed by the Pennsylvania Society of the Colonial Dames of America in 1914, an enormous bronze tablet commemorated Gen. John Forbes's military expedition against the French and Indians at Fort Duquesne. This historical marker titled "Forbes Road – 1758" reads, "This tablet marks the site of a giant oak which stood on the northerly side of the road built in 1758 by Brigadier General John Forbes on his Military Expedition against the French and Indians at Fort Duquesne (now downtown Pittsburgh)." Originally located at 6805 Penn Avenue, on the north side of the street near Linden Avenue, the stump of the giant oak was removed in the 1990s. It is rumored that when the tree was cut down in 1909, the sword of an English officer was found in the tree. A replica of the bronze plaque and the stump were erected recently in Mellon Park, just steps from the site of the Point Breeze Hotel. (CMA.)

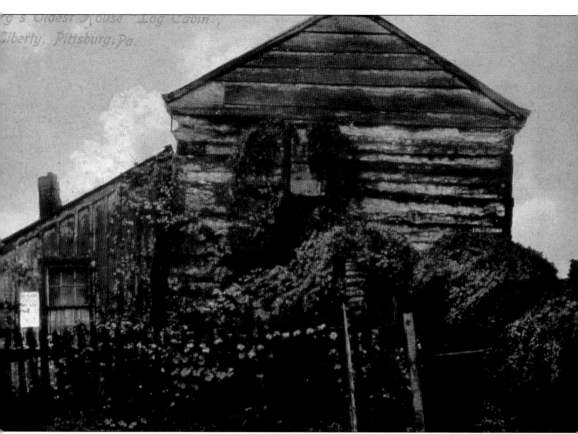

g's Oldest House 'Log Cabin', Liberty, Pittsburg, Pa.

From this log cabin that stood to the west in present-day East Liberty, Penn Avenue has been known by several names—Great Road to the West, Greensburg Pike, Forbes Road. Penn Avenue was paved with rocks as early as 1817. But by the 1870s, it was lined with round wooden blocks with the ends turned up. Gen. George Washington surveyed the road that is now Penn Avenue. This Historical Society postcard of a log cabin located on now Penn Avenue features captioning in the upper left-hand corner which reads "Pittsburg's Oldest House 'Log Cabin', East Liberty Pittsburg, Pa." Pittsburgh was spelled Pittsburg without the *h* from 1891–1911 as deemed by the US Board of Geographic Names (now known as the US Geographical Board). The city so protested that the *h* was returned to the current (and former) spelling of Pittsburgh. (AGS.)

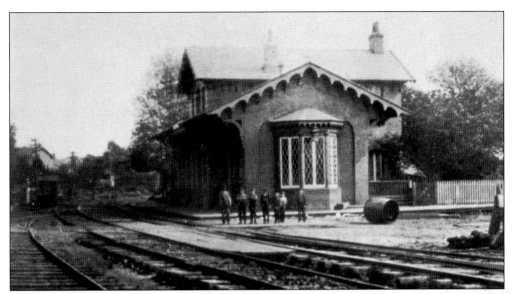

The first train consisting of a wood-burning steam locomotive with three passenger cars arrived from Philadelphia in 1852. Two years later, the Pennsylvania Railroad completed its main line to Chicago, therefore providing passenger and freight service from the East to the Midwest. From the opening of the East Liberty Station in 1854, a total of 26 trains a day transported residents to and from town. (AGS.)

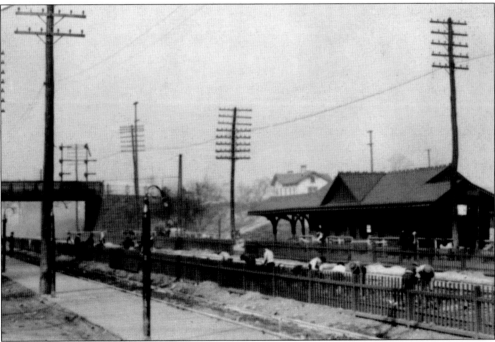

Two train stations existed in Point Breeze, demonstrating the wealth and prominence of the area during Pittsburgh's Gilded Age. Named after Judge Wilkins's estate, the Homewood Station was located near the John Murtland estate near today's North Homewood Avenue. The second station was located at North Dallas Avenue and Simonton Street. Neither remains today. Both stations were linked to the enormous East Liberty Station. (AGS.)

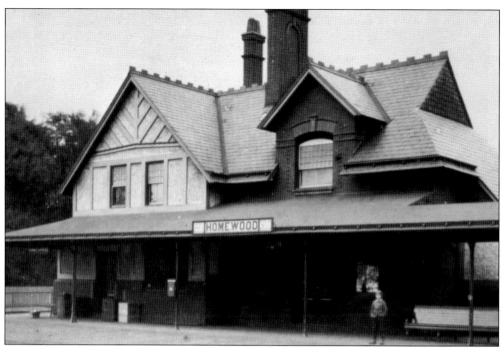

This later image of the Homewood Station, taken in the 1890s, reveals a larger station—a testament to the growth of Point Breeze's prominence and use. All three railroad stations could link a traveling Point Breeze resident to anywhere in the continental United States. Train stations were the travel equivalent of today's airports. The Homewood Station was located near the present-day Homewood Station of Pittsburgh's East Busway. (AGS.)

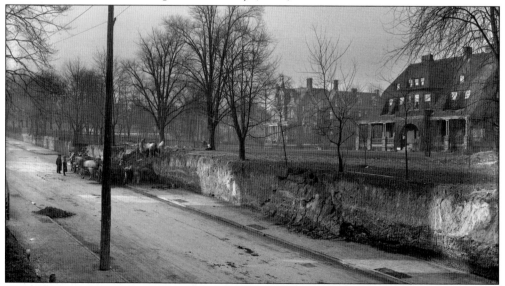

Chester Manor, the estate of John Morrow Murtland, was located off North Homewood Avenue. As one of the first residents in Point Breeze, Murtland acquired a sizable amount of properties predominantly located in present-day North Point Breeze. Although his vocation was detailed as a "downtown broker," Murtland served as director for the American Bank in downtown Pittsburgh in the mid-1800s in addition to his many other ventures. (ASC.)

Two

PITTSBURGH'S MOST OPULENT NEIGHBORHOOD

John Murtland's estate incorporated a substantial corner near the railroad in present-day North Point Breeze. Murtland and his family were also some of the first members of the Calvary Episcopal Church on Highland Avenue in Shadyside. As one of the earliest residents and landowners in Point Breeze, Murtland is honored with the street named after him. (ASC.)

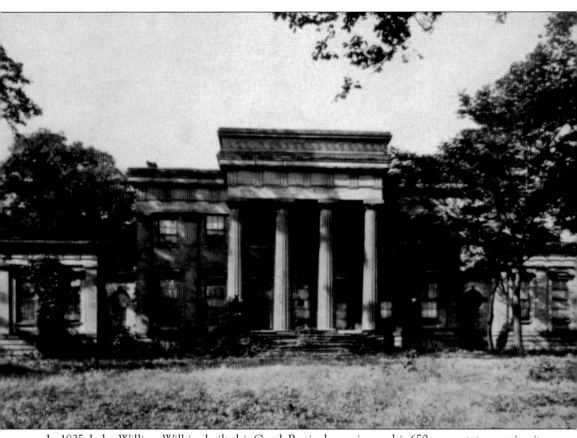

In 1835, Judge William Wilkins built this Greek Revival mansion on his 650-acre estate, naming it Homewood. In addition to his positions as a US senator and representative as well as an ambassador to Russia and the former secretary of war under President Tyler, Wilkins was a Pittsburgh banker and judge of the US District Court for Western Pennsylvania. Wilkins's wife, Matilda Dallas, was the daughter of Alex. J. Dallas of Philadelphia (US Treasury secretary in 1814) and a sister of George M. Dallas (vice president under President Polk). Dallas Avenue is named for Matilda Dallas. Homewood was located near the what is now the corner of Reynolds and South Murtland Streets. The private road from Wilkins's estate into Oakland would become Wilkins Avenue. The grounds included a dacha, or weekend cottage, inspired by his tour of duty as a Russian ambassador. The mansion was noted for its library, stuccoed ceilings with gold leaf inlays, and Italian marble fireplaces with figures of dancing Greek girls. The site of many parties and dinners, the stately mansion entertained guests such as Daniel Webster and Gen. Andrew Jackson. (AGS.)

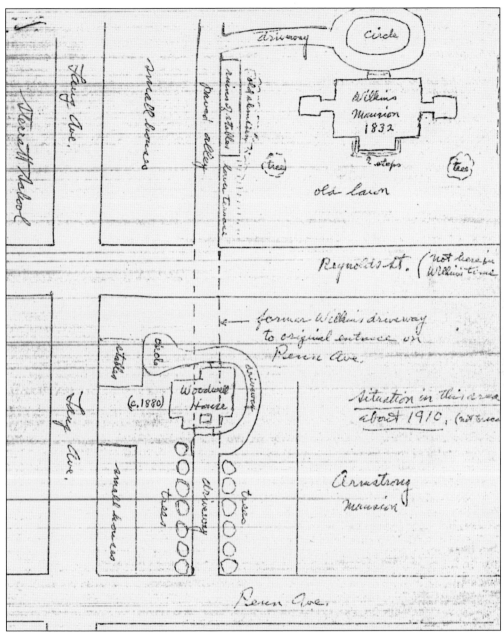

This drawing illustrated by local resident and author Hartley Fleming details the Homewood mansion. At the time Fleming drew this map, however, the estate was owned by William Coleman, who purchased the property after Wilkins's death in 1865. Coleman was related to Lucy Carnegie. According to the letter from Hartley G. Fleming to Robert C. Alberts, dated October 2, 1972, Fleming recalls playing in and around the vacant manse as a child: "The house stood open and abandoned for many years. It was played in by Sterrett school children, including me, and slept in by hoboes, and yet most of the glass was intact, and much of it original, as could be inferred from the slightly distorted appearance of things seen through it." In his will, Wilkins bequeathed 178 acres, which would become Homewood Cemetery. The Homewood estate was razed in 1924. (AGS.)

In 1903, Frederick Law Olmsted Jr. rebuilt Beechwood Boulevard, making it an even more fashionable area in which to live. According to the *Pittsburgh Blue Book of 1914*, at least 30 families lived on Beechwood Boulevard between Fifth and South Dallas Avenues. This area became an extension of the Penn Avenue Millionaires' Row. The castle-like Lyndhurst mansion, owned by the Thaw family, is shown in profile in the background. William Thaw first amassed his fortune through the ownership of steam canal boats, and with the rise of the railroad, Thaw divested the canal business and invested in the Pennsylvania Railroad. A prominent philanthropist, Thaw died in 1889 before the completion of his house designed by Theophilus Parsons Chandler Jr. Harry Kendall Thaw was the youngest of William's six children. Violent and paranoid almost since birth, he spent his childhood bouncing from private school to private school. His father's name and social status eventually got him into Harvard University, where he was allegedly credited with the invention of the speedball—an injected combination of cocaine and heroin or morphine. (ASC.)

Harry Thaw's precarious nature followed him throughout his adult life. Thaw stood trial in the famous 19th-century "Trial of the Century" for murdering prominent architect and fellow lothario Stanford White over the affections of Thaw's wife, showgirl Evelyn Nesbit. Thaw ultimately testified that he had experienced a "brainstorm," meaning a moment of temporary insanity. (AGS.)

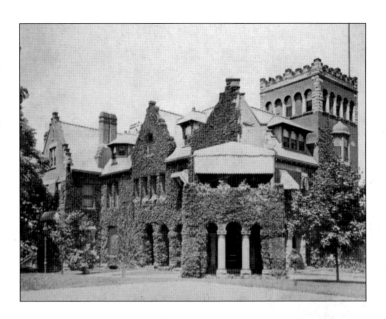

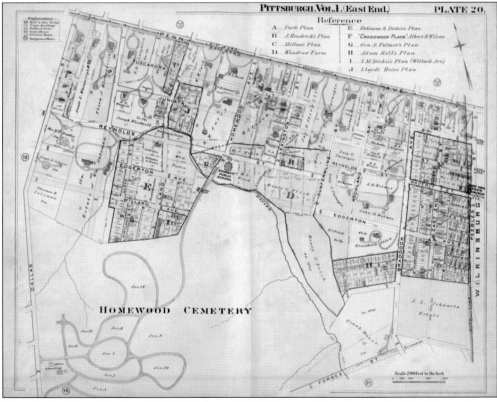

From the height of Pittsburgh's Gilded Age, this 1898 map reflects the vast land holdings of some of the wealthy families who lived in Point Breeze. To illustrate, William Coleman owns part of the Wilkins estate; 178 acres became Homewood Cemetery. As a companion piece, an 1899 plat map of present-day North Point Breeze can be viewed on page 50. (ASC.)

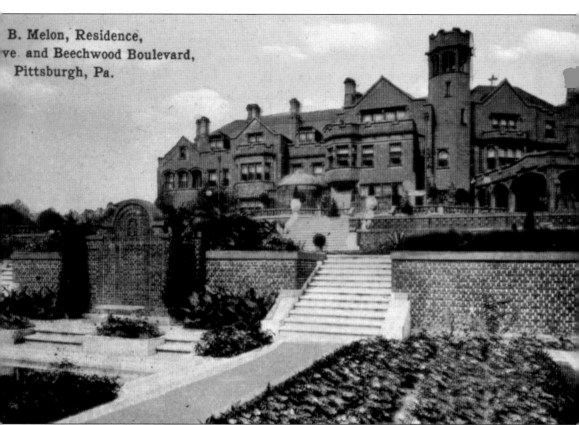

B. Melon, Residence,
ve. and Beechwood Boulevard,
Pittsburgh, Pa.

According to late Pittsburgh History and Landmarks Foundation (PHLF) historian Walter C. Kidney's book *Pittsburgh Then and Now*, "Fifth Avenue east of the Oakland Civic Center was a municipal showplace, with many of the city's prosperous in residence, but no house quite matched that of Richard Beatty and Jennie King Mellon, at Fifth Avenue and Beechwood Boulevard. A work in the Tudor style by Alden & Harlow, it was finished in 1911. It had a 'butterfly plan' that offered a variety of views and abundant workmanship that included a marble staircase such as Victorian England had never seen. Its garden terraces towards Beechwood Blvd. were remarkable in their own right." (AGS.)

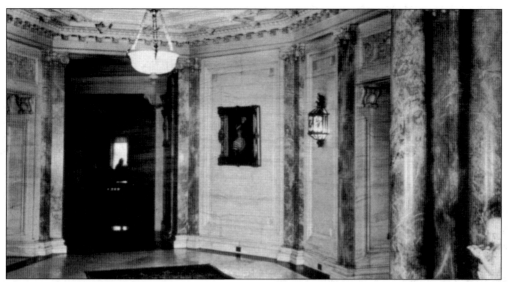

Per Kidney's book *Pittsburgh Then and Now*, "When the R. B. Mellon house came down around 1940, it was cannibalized in a remarkable and clever manner, with much of its decorative work and masonry reused in Mount Saint Peter, a Catholic church in the nearby town of New Kensington. The terraces remain as one element of Mellon Park, a favorite East End resource that adjoins the Pittsburgh Center for the Arts which is located in the Marshall House of 1912." (AGS.)

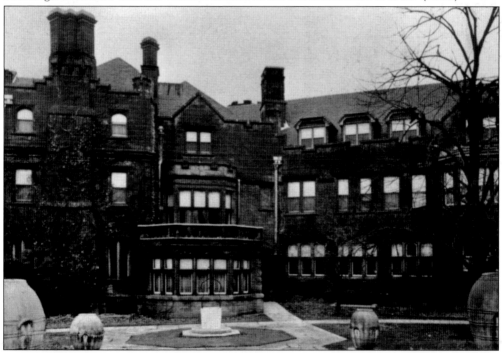

This massive mansion had a total of 65 rooms, with 17 functioning bathrooms. When the house was razed around 1940, many of the materials used in the mansion were repurposed at Mount St. Peter Church. Unfortunately, this was one of the few times that the materials from these magnificent homes were reused. The majority of the time, it was more cost-efficient to level these mansions than maintain them. (AGS.)

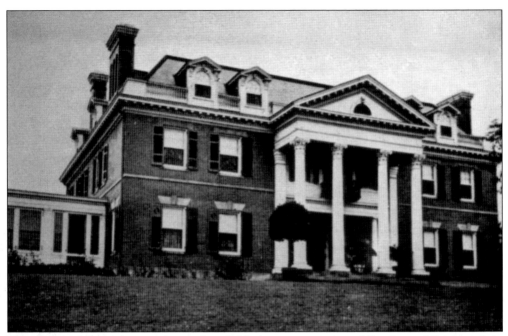

This Colonial Revival mansion stood on Fifth Avenue, just west of Beechwood Boulevard, in what is now Mellon Park. Alden & Harlow were the architects for the house named Beechwood, and its former owner, William Nimick Frew, was president of the Carnegie Library and Institute. Frew also served as director of a number of Pittsburgh-based corporations and banks. (AGS.)

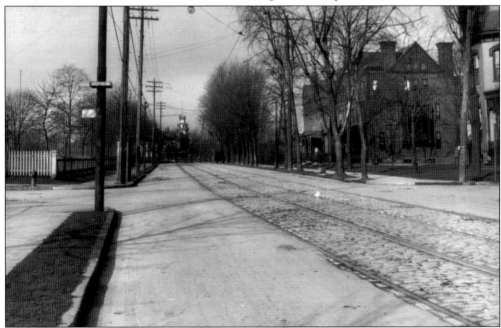

This street scene, captured at the corner of South Dallas and Penn Avenues, was taken on November 27, 1907. As part of the city's photography collection, the image served as a record of the street maintenance and repair. On the left side is the "Dallas Av." street sign, with a smaller and illegible (due to size) sign below. (ASC.)

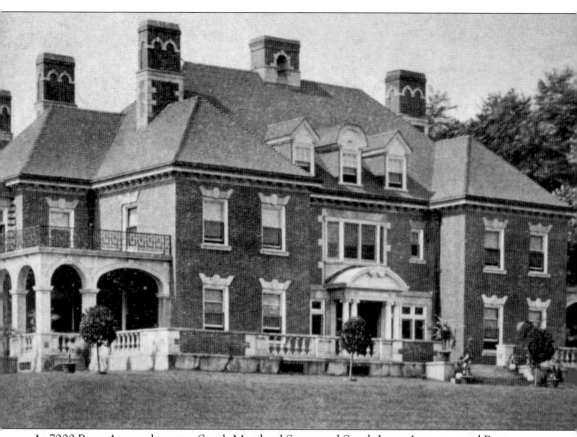

At 7000 Penn Avenue between South Murtland Street and South Lang Avenue, stood Penrose, the mansion of Martha Jean Porter Armstrong, widow of the Armstrong Cork Company founder, Thomas Armstrong. Famous for his integrity in business and a pioneer in manufacturing cork and linoleum products, Armstrong founded the Armstrong Cork Company in 1860. Cork, known for its buoyancy, was used in life jackets. This Armstrong product saved the lives of many shipwreck survivors, including the survivors of the *Titanic*. Mr. Armstrong died in 1908. Alden & Harlow were the architects of the Colonial Revival house. To the east of Penrose and a block and a half west of Henry Clay Frick's Clayton stood the Joanna (Mrs. Joseph R.) Woodwell estate and on either side of her home were the estates of her sons, John Woodwell and William E. Woodwell. Hardware merchant Joseph R. Woodwell, son of the founder of Joseph Woodwell & Co., was also a widely known artist. Note Hartley Fleming's drawing at the beginning of this chapter. (AGS.)

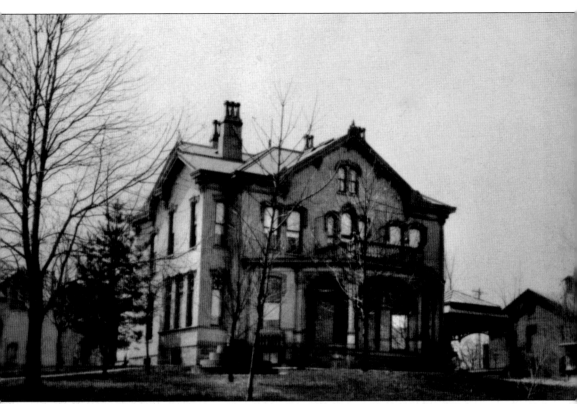

Henry Clay Frick and his bride, Adelaide Howard Frick, purchased Homewood, an 11-room, Italianate-style home located at the corner of Penn and South Homewood Avenues in Pittsburgh's residential East End neighborhood. From 1882 to 1883, Pittsburgh architect Andrew Peebles made interior and exterior modifications to the home, renamed Clayton. The house served as the family's primary residence from 1882 to 1905. The Fricks' first son, Childs (1883–1965), was born in March. Their daughter, Martha (1885–1891), was born a year later, followed by Helen Clay Frick (1888–1984) and a fourth child, Henry Clay Frick Jr., who died shortly after birth in 1892. (AGS.)

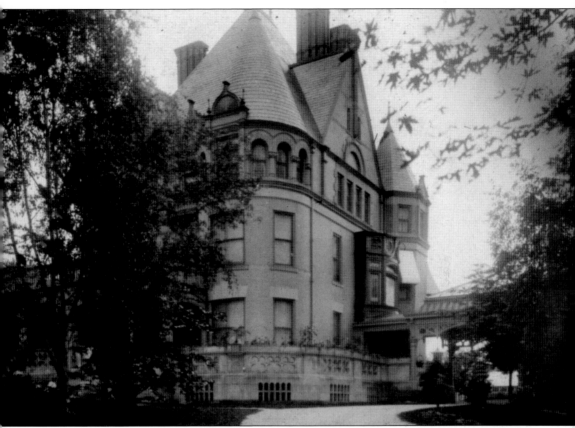

Frederick John Osterling (1865–1934) is credited with enlarging the Frick home around 1892 into its present-day 23-room mansion. Osterling added two floors and recreated Clayton in the style of a Loire Valley château. A prolific architect, Osterling was born and trained in Pittsburgh with Joseph Stillwell. He designed the Union Trust Building on Grant Street and the Times Building (Magee Building) on Fourth Avenue, as well as numerous other buildings and homes. As Allegheny County architect, Osterling's career suffered from controversy in regard to his intended altered plans to the H.H. Richardson Allegheny County Courthouse, as well as a very public lawsuit filed by H.C. Frick. But he continued to maintain an office on Isabella Street in Pittsburgh's Northside until his death. (AGS.)

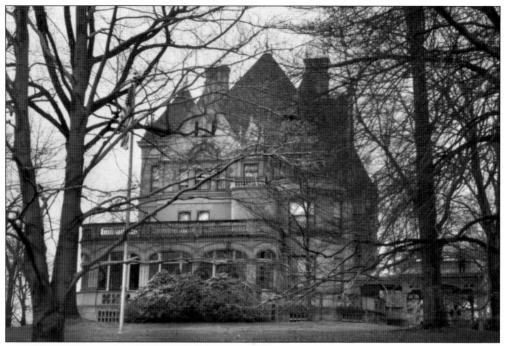

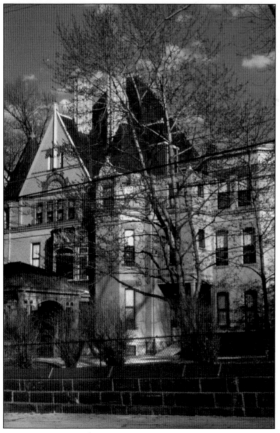

Of all the estates and palatial homes that once graced Penn Avenue, the only one that remains in Point Breeze in its original state is Henry Clay Frick's Clayton. Frick's surviving daughter, Helen Clay Frick, bequeathed the home and its grounds to the City of Pittsburgh at the time of her death. (AGS.)

The restoration of Clayton began soon after Helen Clay Frick's death in November 1984. According to the Frick Art Museum and Historical Center, "The home's historic significance was assessed in terms of its importance as an example of domestic architecture of the period, its furnishings, and its status as one of the few intact homes from Pittsburgh's lost 'Millionaire's Row.' " (AGS.)

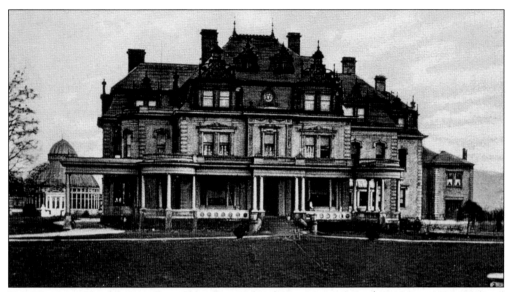

H.J. Heinz purchased Greenlawn (the former Hopkins mansion) for $35,000 in 1892. He paid $10,000 in cash, $5,000 payable in one year, and $20,000 in three years at five percent interest. His property occupied the full block of Penn Avenue between North Lang Avenue and North Murtland Street. This postcard of Greenlawn offers a glimpse of the estate, which includes the mansion and a small conservatory. (AGS.)

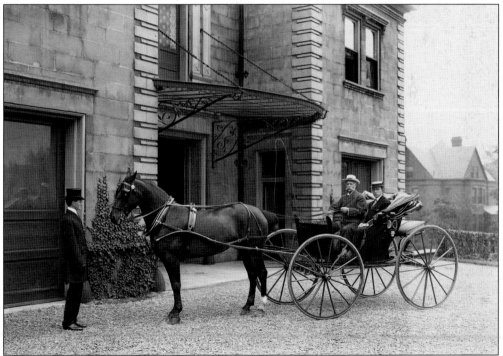

Posed with his son Clifford, H.J. Heinz is shown at the reins of an open carriage with a coachman standing to the left. The buildings used for Heinz's garage/stable and private museum still exist on a small residential street in North Point Breeze (as noted on page 112). The estate's decorative wrought-iron fence still circles the former grounds as well as the estate manager's house. (HHC.)

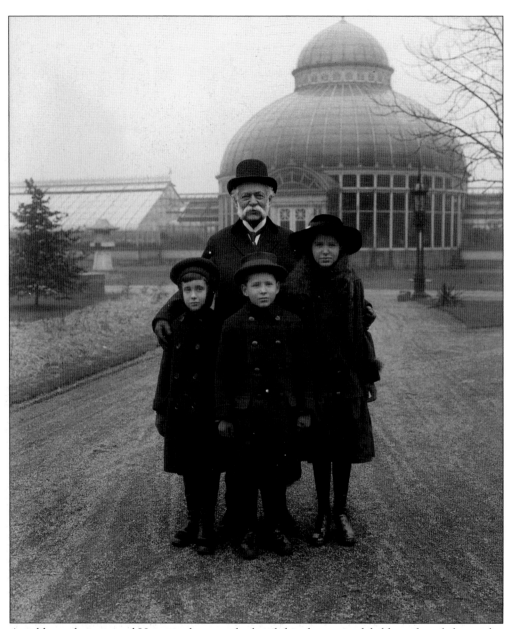

An older and very proud Heinz is photographed with his three grandchildren, from left to right, H.J. Heinz II (future chairman of the board), John Jr., and Sarah Given. In the background, a conservatory consisting of 10 greenhouses graces the estate grounds. Included on the estate was Heinz's own private museum that housed his extensive artifact and watch collection. By 1915, it contained over 5,000 possessions and was overseen by a full-time curator. On Sunday afternoons, Heinz opened the grounds to the public. In an account of those outings, many people looked forward to a sunny Sunday afternoon on the grounds of Greenlawn or Clayton, the estate of Heinz's neighbor, Henry Clay Frick, down the street. Years of hard work and innovation had made H.J. Heinz and his products internationally known and respected. In 1919, in the year of the 50th anniversary of the founding of Heinz & Noble, H.J. Heinz died of pneumonia at Greenlawn. (HHC.)

Owned by John B. Jackson, president of the Western Pennsylvania Institute for the Deaf and Dumb (now the Western Pennsylvania School for the Deaf), Pennlawn was located at 6842 Penn Avenue, on the south side of the street between South Dallas Avenue and South Linden Street. Nearby neighbors included the Woodwells and Martha Jane Porter Armstrong. (AGS.)

H.C. Frick's grandfather, Abraham Overholt, owned the Overholt Whiskey Distillery in West Overton, Pennsylvania. Overholt was a leading figure in the rural town 40 miles southeast of Pittsburgh. A. Overholt & Company currently distills Old Overton, a rye whiskey that was rumored to be a favorite of famed gunslinger Doc Holliday. (SLL.)

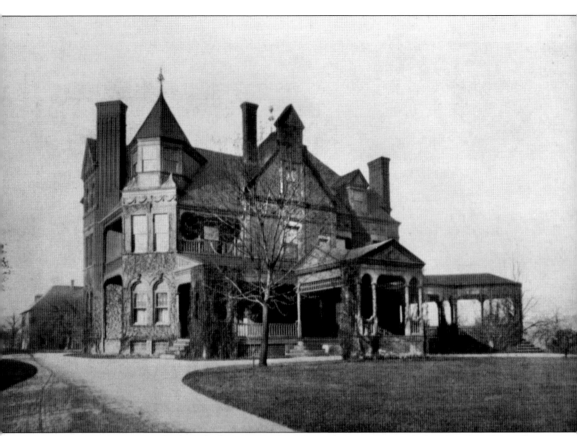

George Lauder was on the board of managers for US Steel Corporation. A Pittsburgh industrialist and engineer, Lauder was also an adviser to his first cousin, Carnegie. Lauder retired in 1901 when Carnegie sold his Carnegie Steel Company to John Pierpont Morgan, thus creating the US Steel Corporation. A cousin to Thomas and Lucy Carnegie as well, Lauder moved to Greenwich, Connecticut, in 1902. Owned by the Reformed Presbyterian Theological Seminary on the south side of Penn Avenue, the Willson Center occupies the site of the former Lauder home on the north side of Penn Avenue (as noted on page 119), while the seminary occupies the Gables, the former home of Durbin Horne (seen on page 38). (AGS.)

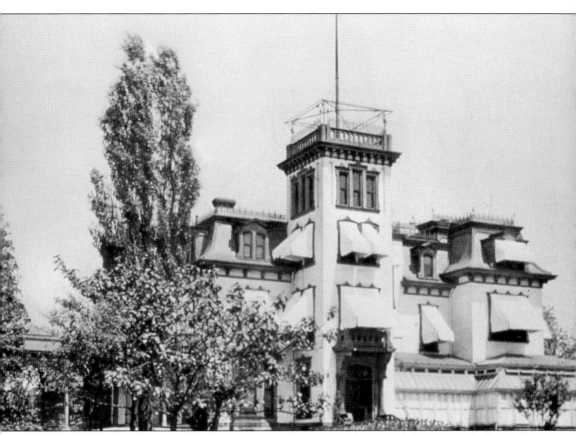

George Westinghouse purchased this property in 1871 as a surprise birthday present for his wife, Marguerite Erskine Walker Westinghouse. Originally, the estate came with a three-story, mansard-roofed house, which was enlarged as the family prospered. But the residence that would become known as Solitude was a Second Empire–style mansion where the Westinghouses and their only child, George III, entertained nightly dinner guests, from presidents and visiting dignitaries to coworkers and their families. "[Marguerite] lives in greater style, entertains more splendidly and wears more gorgeous, varied and elegant toilets, has more and finer diamonds than any woman in Pittsburg," Adelaide Nevin wrote in the local *Social Mirror* in 1888. "Her table appointments are simply superb, the entire service being of solid silver and gold . . . and the cut glass, Sèvres, Dresden and other fine porcelains are worth a small fortune." Marguerite named Solitude for the small Catskills settlement of the same name that was located near where she grew up, which had disappeared before the Civil War. (AGS.)

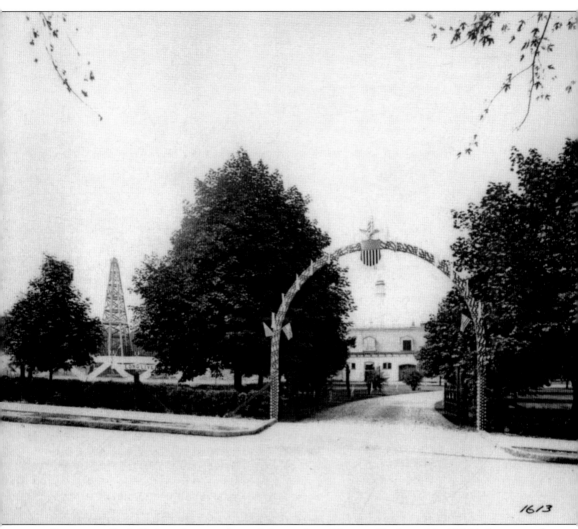

Four gas wells drilled on the estate's south lawn along Thomas Boulevard in 1884 led to several dozen inventions for the control and distribution of natural gas. Westinghouse's ideas were the basis for founding a company to distribute gas in the Pittsburgh area. Knowledge gained from this work pointed him in the direction of a better distribution system for electric current. After striking gas in the summer of 1884, Westinghouse erected a 60-foot pipe from the mouth of the well, along with a bundle of oil-drenched rags hoisted by pulley to the top of it. When the well was uncapped, a burst of flames shot 100 feet into the night sky, then settled down to a steady plume of flame. It was reported that people a mile away could read their newspapers through the light emitted from the flame. By 1886, Westinghouse had invented a reduction valve that permitted high-pressure gas from the well to be delivered at low pressure at the point of use. He began distributing natural gas to his Point Breeze neighbors, thus establishing the Philadelphia Company, which would later become today's Equitable Gas Company. (NPBPDC.)

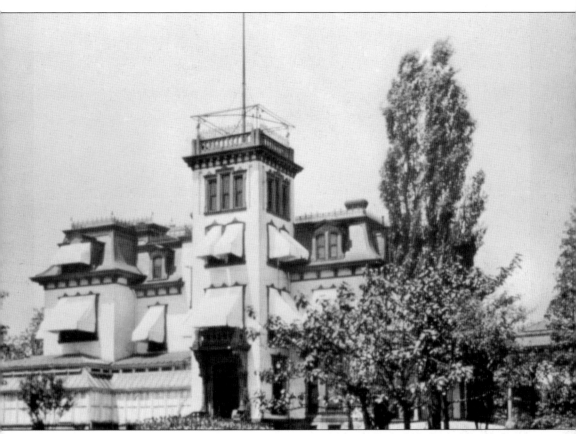

In late July 1888, the brilliant young Serbian inventor and engineer Nikola Tesla left New York to visit George Westinghouse and serve as a consultant for the Westinghouse company. The two joined forces to promote their alternating current (AC) system against Thomas Edison and his direct current (DC) system in the so-called War of the Electric Currents. When Tesla returned to New York to further his other projects and ideas with inventors and patrons to fund them, he and Westinghouse kept in touch. Westinghouse's compassion for inventors and his desire to help them promote their ideas stemmed from the countless refusals he received before his own Air Brake Company was accepted and became successful. Though Tesla lived to see his dream of an AC system encompass the world, he died penniless and alone on a snowy New York City day in January 1943 at the age of 86. (AGS.)

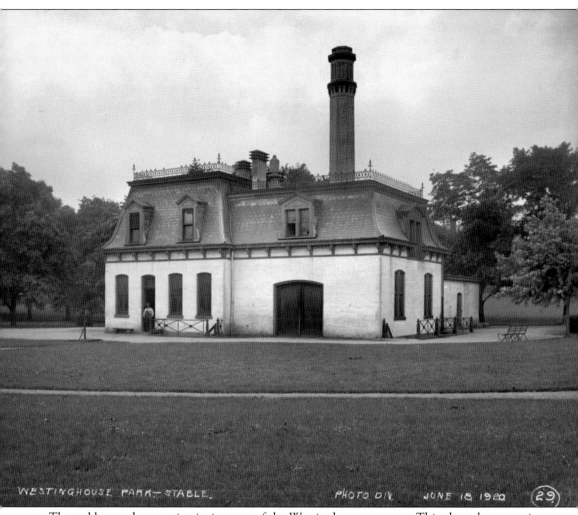

WESTINGHOUSE PARK—STABLE. PHOTO DIV. JUNE 18, 1920 (29)

The stable was the most intriguing part of the Westinghouse property. This glass-plate negative image captures the two-story, Second Empire–style brick stable that also served as Westinghouse's laboratory. The tunnels below the property allowed for easy movement from one part of the estate to the other in complete privacy. Westinghouse's workroom was complete with drawing board and a beloved horse, although stuffed. It was here that he conducted experiments with alternating current for his heated and well-publicized battle against Thomas Edison in the race to safely place electricity in private homes at the start of the 20th century. (ASC.)

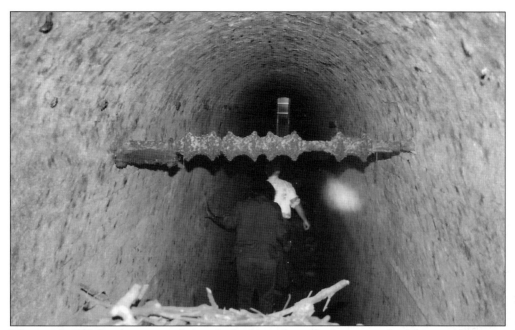

The nearly 200-foot-long, rounded-arched subway from the house to the laboratory remains completely intact, including the tunnel's ceiling rods, from which Westinghouse suspended electrical lines. Another tunnel, now in need of repair, ran from the railroads to the house to usher in dignitaries from Westinghouse's sidecar. The Westinghouse family and their staff could move throughout the property via these underground tunnels. (Additional images and information can be found in chapters 6 and 7.) (NPBPDC.)

Carbarns stored public streetcars, but they also provided storage for private cars. Hartley Fleming's memoir recalls the Flemings' Oldsmobile, an open touring car, housed at the "old Reynolds place," which was a deserted farmhouse and stable on a Penn Avenue property running to the tracks along Lexington Avenue. Fleming's school days at Shadyside Academy drew heavy competition, with Claude Benedum driving his Simplex and Lou Klingelhofer his Stutz Bearcat. (NPBPDC.)

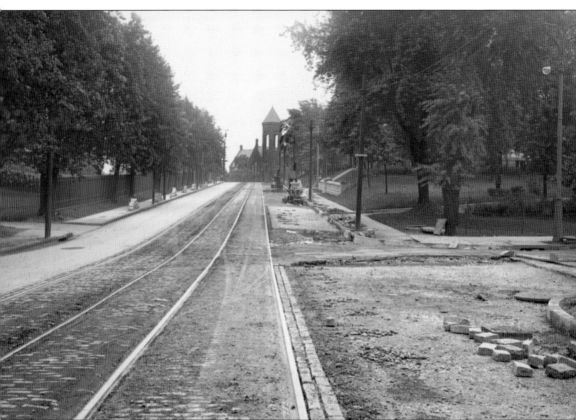

Two public structures built a year apart are among the oldest extant buildings in the zone. The first is the 1887 Romanesque Point Breeze United Presbyterian Church at Fifth and Penn Avenues. The church stands directly across from where the Point Breeze Hotel existed in the last century. The congregation was organized on December 5, 1887, and the chapel was finished later that month. The property was deeded to the church, and the cost of the lot and the building was in the neighborhood of $60,000. Represented in the city of Pittsburgh by J.F. Schoomaker, New York architect Lawrence B. Valk's drawing of the church shows that the Richardsonian Romanesque character of the initial design was considerably "thinned out" in the actual construction under contractor George S. Fulmer. The original tower had an octagonal spire. (AGS.)

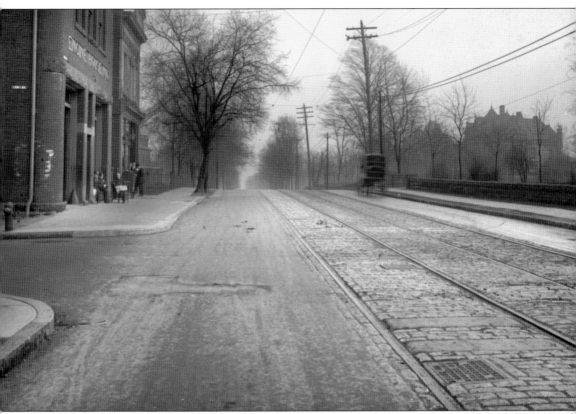

The second public structure is the 1888 Romanesque Engine House No. 16 at Penn and North Lang Avenues. In the background is the silhouette of Clayton, Henry Clay Frick's mansion. Donald Scully, a former Point Breeze resident, recalls memories of when the engine house opened "with gleaming golden bells and the fire wagons with shiny red leather interiors." Scully remarked that it was quite a sight to see the horses pulling the fire wagon from Engine House No. 16 in response to a fire call, with "their manes flying, hooves thundering down Penn Avenue." There was an infamous horse named Joe at the engine house who slept lying down. He would sleep so soundly that most fire alarms would not awaken him. The firefighters tied a string of tin cans together to wake him up, but instead of rousting the horse to his harness, Joe the horse woke up and bolted out of the engine house and toward the fire. (ASC.)

In 1849, Joseph Horne founded the Joseph Horne Company, which would remain a leading Pittsburgh department store for the next 130 years. Born in 1854, five years after the Horne Company was founded, son Durbin followed his father and several siblings into the family business. Durbin Horne is credited with the rapid expansion of the company, which survived two great fires and savage competition. Incorporated as the Joseph Horne Company at the turn of the last century, the company secured itself as a Pittsburgh institution, with Durbin succeeding his father as president until 1915. Father and son were also members of the elite South Fork Fishing and Hunting Club on Lake Conemaugh to the east. The club was a refuge from the Pittsburgh heat, dirt, and noise. Other members included Horne's neighbors H.C. Frick, Andrew Mellon, and Joseph R. Woodwell. The club's poor maintenance of the South Fork Dam caused the 1889 Johnstown Flood. The mansion, known as the Gables, is currently in use by the Reformed Presbyterian Theological Seminary on the south side of Penn Avenue. (SLL.)

Upon the bequeathment of Judge Wilkins, the creation of Homewood Cemetery began with an insightful legacy of incorporators. In addition to being a final resting place for many of the city's wealthy and famous, the cemetery named after Wilkins's estate was also a business requiring the acumen of the city's leading citizens. Noted Point Breeze residents include W.W. Card, A.H. Childs, H.J. Heinz, and T.M. Armstrong, among others. (FF.)

THE INCORPORATORS
OF HOMEWOOD CEMETERY

	Elected		Elected		Elected
William Rea	1878	E. M. Bigelow	1887	Edward J. Taylor	1915
J. B. Sweitzer	1878	George W. Dilworth	1889	E. E. Batchelor	1915
Geo. P. McBride	1878	H. C. Frick	1892	Arthur V. Davis	1915
John H. Dalzell	1878	William H. Rea	1893	A. J. Kelly, Jr.	1915
Chas. Meyran	1878	M. K. Salisbury	1893	Clarence Burleigh	1915
James W. Brown	1878	J. M. Schoonmaker	1893	Alex. R. Peacock	1915
Henry Holdship	1878	John C. Kirkpatrick	1895	Hon. Rob't. S. Frazer	1915
William H. Smith	1878	W. S. Foster, M. D.	1896	William Allen	1915
Alexander Nimick	1878	James R. Mellon	1896	Southard Hay	1916
A. S. Murray	1878	David Woods	1896	W. W. Blackburn	1917
D. A. Stewart	1878	A. P. Burchfield	1896	George S. Davison	1920
John Scott	1878	T. M. Armstrong	1896	Thos. Reed Hartley	1920
O. P. Scaife	1878	Hon. George Wilson	1896	William M. Furey	1920
Thomas Wightman	1878	R. Wolff, Jr.	1896	M. L. Benedum	1920
Marcellus Coye	1878	E. H. Jennings	1902	J. B. Yohe	1920
F. LeMoyne, M. D.	1878	W. Harry Brown	1902	Stewart A. Davis	1920
Reuben Miller	1878	John Z. Speer	1902	Howard A. Noble	1922
A. E. W. Painter	1878	Jos. R. Woodwell	1902	Harry W. Croft	1923
John H. Ricketson	1878	Hon. W. D. Porter	1902	Charles A. Dickson	1923
Malcolm Hay	1878	W. L. Abbott	1902	James B. Essman	1923
Chas. W. Batchelor	1878	J. G. Stephenson	1902	Ernest Hillman	1923
James Herdman	1878	H. J. Heinz	1902	Robert T. Morrow	1923
A. H. Childs	1878	John F. Steel	1904	William L. Rodgers	1923
P. N. Guthrie	1878	R. B. Ward	1908	William S. Stimmel	1923
James J. Donnell	1878	H. C. Bughman	1908	George E. Alter	1926
William Metcalf	1878	David P. Black	1909	John S. Craig	1926
J. D. Collingwood	1880	J. I. Buchanan, LL.D.	1909	Walter J. Guthrie	1926
W. H. Berger	1880	D. M. Clemson	1909	A. L. Humphrey	1926
William Clark	1880	George B. Gordon	1909	Eugene W. Pargny	1926
Alexander Murdoch	1880	T. Clifton Jenkins	1909	Charles E. Benson	1928
Thomas M. Jones	1886	Wallace H. Rowe	1909	John L. Porter	1928
C. A. Carpenter	1886	Thomas Rodd	1909	S. LaRue Tone	1928
W. K. Woodwell	1886	Lee S. Smith	1909	Homer D. Williams	1928
J. B. Hill	1886	James R. Sterrett	1909	Charles A. Brooks	1930
J. H. Lippincott	1886	James Scott	1909	Frank A. Evans	1930
Joseph Abel	1886	Albert L. Schultz	1909	Charles A. Fisher	1930
John Semple, M. D.	1887	Chas. L. Taylor	1909	James H. Lockhart	1930
Hill Burgwin	1887	A. H. Burchfield	1915	James C. Rea	1930
W. W. Card	1887	C. D. Armstrong	1915	Wm. MacGilvray Shiras	1930

BOARD OF MANAGERS
James R. Mellon, *President*

Daniel M. Clemson, *First Vice President* James C. Rea, *Treasurer* George S. Davison

Charles D. Armstrong, *Second Vice President* W. W. Blackburn Howard A. Noble

William Allen, *Superintendent* R. R. M. Thorne, *Secretary*

In a lecture titled "Exquisite Death: the Art of Victorian Mourning" presented at the Frick Art and Historical Center on October 1, 2010, Dr. Elisabeth Roark of Chatham University articulated that the idea of cemeteries as lush greenways and manicured parks was very much celebrated in Victorian times. Coming to the cemetery for the day to picnic and pay respects to deceased relatives was considered a family event. (FF.)

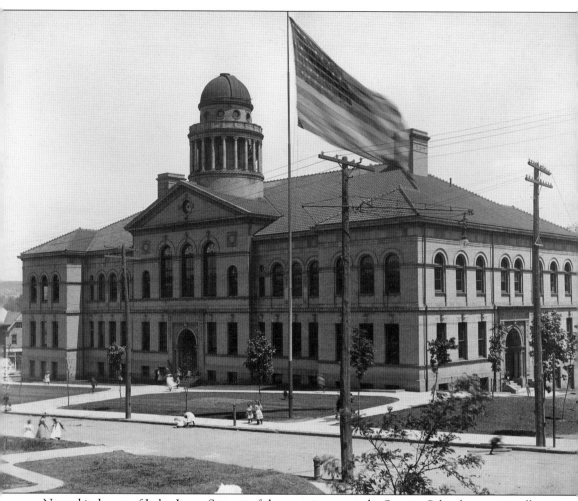

Named in honor of Judge James Sterrett of the superior court, the Sterrett School was originally built in 1840 where the Homewood Cemetery is currently located. However, in 1898, the school was moved to its present location at 7100 Reynolds Street. The October 21, 1899, issue of the *Dispatch* disclosed the total cost of building the school to be $100,000 (roughly $2,777,777.78 today). The building was deemed fireproof, and an observatory graced the top of the structure. Henry Clay Frick donated a telescope, which was valued at $10,000 at the time. It was reported that many of the city officials watched Halley's comet from the school's observatory in May 1910. According to school records, young Childs Frick attended the Sterrett School for one year. The powerful telescope, however, was removed for surveillance work during World War I, and the observatory was eventually eliminated due to damage and neglect. In 1979, the school became known as the Sterrett Classical Academy, housing grades six through eight. (CMA.)

Three

THE PARK PLANS

Real estate entrepreneurs took advantage of the growing real estate market. In 1885, the area known as the Boulevard Park Plan was laid out. The original plan of boulevard streets, with grassy islands planted with ornamental trees, still exists today; an ornamental wrought-iron gate at the start of McPherson and now Washington Boulevards was removed in the 1980s. This 1912 photograph shows the repaving of Thomas Boulevard at North Linden Avenue. (ASC.)

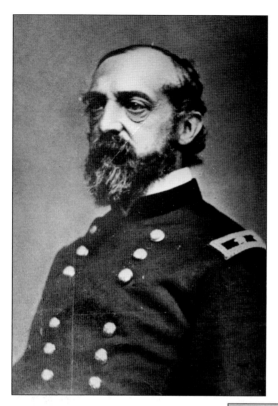

Meade Street was named for Gen. George Meade, a Philadelphia native who served in the Mexican War during the 1840s. During the Civil War, he was appointed commander of the Army of the Potomac and led Union forces at Gettysburg. Meade was nicknamed "Old Pills" due to numerous combat injuries. In his last years after the war, Meade became commissioner of Fairmont Park in Philadelphia, where he died in 1872. (NPBPDC.)

A graduate of West Point, Gen. James Birdseye McPherson became a Civil War general, taking command of the Army of Tennessee under Sherman. Due to his rapid and decisive movement of troops, McPherson earned the nickname "the Whiplash of the Army." In 1864, McPherson was killed at Kennesaw Mountain, near Atlanta. Sherman wept when the body of McPherson was brought to him. (NPBPDC.)

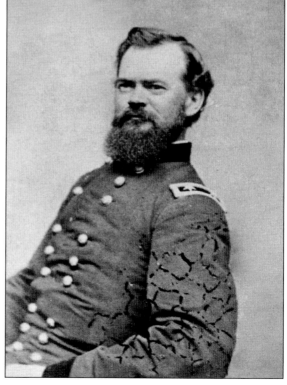

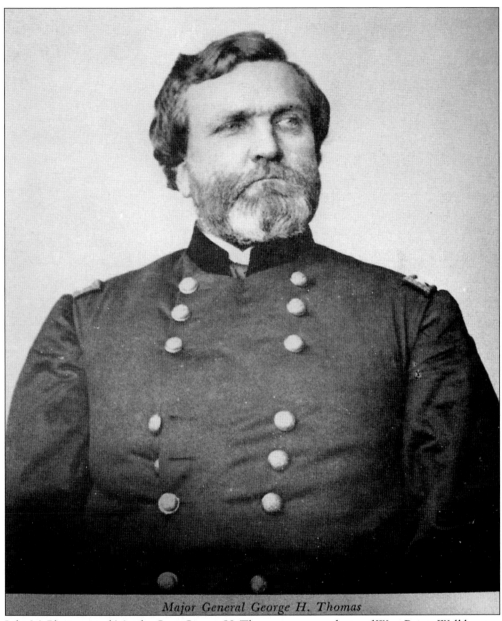

Major General George H. Thomas

Like McPherson and Meade, Gen. George H. Thomas was a graduate of West Point. Well known as "the Rock of Chickamauga," General Thomas earned this nickname after refusing to give way to advancing Southern troops. His success at Chickamauga earned his being named head of the Army of the Cumberland, which made up half of Sherman's Atlantic forces. General Thomas was named commander of the Military Division of the Pacific, and in 1869, he was offered a nomination to run for presidency. Thomas declined, citing that he did not have the necessary control over his temper to run. Thomas died in California in 1870. Thomas Boulevard is named in his honor. Real estate magnet G.D. Simen is credited for naming many of the streets in North Point Breeze, including Thomas, McPherson, and Simonton. Although Simen never lived in Point Breeze, plat book maps reveal that he owned four houses: three in the island blocks of the boulevards and one at the former site of Rockwell International. (NPBPDC.)

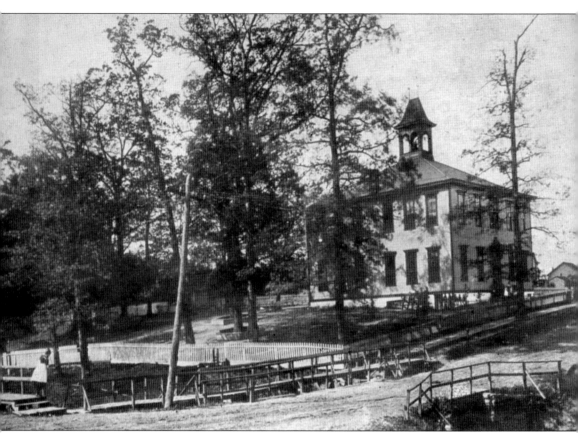

Located at the corner of Hamilton Avenue and Clawson Street, the Homewood School first opened 1876. Seen in this 1877 image, the school derived its name from the 650-acre estate of Judge William Wilkins, a former secretary of war under 10th president John Tyler, former US senator, and ambassador to Russia. This eight-room frame building opened following the area's incorporation into the City of Pittsburgh as the 21st Ward. In 1891, a new school building was constructed at the corner of Hamilton and North Lang Avenues, with 12 new classrooms and a gymnasium. By 1915, the school contained 27 classrooms, a gymnasium, a faculty dining room, and two administrative offices. Another addition was added to the building in 1958, and in 1962, four new buildings containing seven "demountable classrooms" were constructed. Homewood School was converted to a City of Pittsburgh magnet school in 1980. (AGS.)

In 1910, Pittsburgh recognized the importance of trees in urban neighborhoods by creating the Shade Tree Commission. Its purpose was to "transport the nature people came to appreciate so fully in Schenley Park to the rest of the city." The commission, however, was rather short-lived, as the Street Tree Division within the Bureau of Parks replaced it in 1914. The Shade Tree Commission's demise followed a general decline in enthusiasm and funding for Pittsburgh's shade tree programs. According to the current Pittsburgh Shade Tree Commission, "The past 20 years of neglect, more poignant than any other point in the city's history, devastated the city's tree populations and the neighborhoods they beautified." The commission was reestablished in 1998, conducting a citywide inventory of its trees. The inventory revealed a far lower number of trees than what the city had estimated; as a proactive result, more trees have been planted, and tree health has been maintained through the reincorporated Shade Tree Commission. (ASC.)

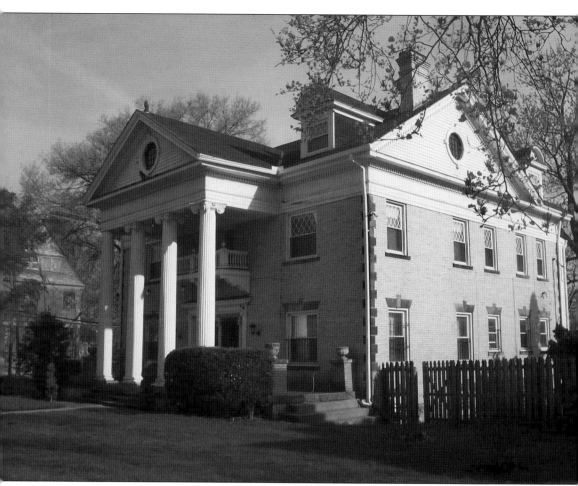

One of the first and remaining examples of the Westinghouse Park Plan is the house at 6901 Thomas Boulevard. The Westinghouse Park Plan intended to attract affluent families by building large upscale homes in the vicinity of the former Westinghouse manse, Solitude. Unfortunately, the developer of the plan went bankrupt during construction, and only five original houses remain; the sixth was demolished. (NPBPDC.)

This house at 6916 Thomas Boulevard is the second remaining example of the Westinghouse Park Plan. Built in 1903, the residence at 6923 Thomas Boulevard is the third of five extant houses that were part of the original Westinghouse Park Plan. The Van Trump family bought the property in 1922, and raised here was James "Jamie" Van Trump, cofounder of the Pittsburgh History & Landmarks Foundation as well as assistant editor, editor, and finally, copublisher of the *Charette* (the journal of the Pittsburgh Architectural Club, later cosponsored by the Pittsburgh chapter of the American Institute of Architects and the Pennsylvania Society of Architects). The other remaining houses are located in the same block of Thomas Street at 6901, 6916, 6949, and 6959. (SLL.)

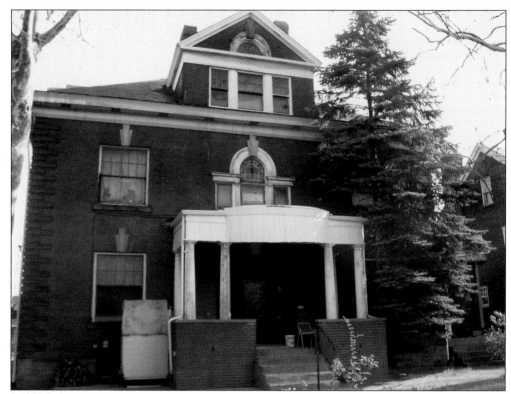

The fourth remaining example of the Westinghouse Park Plan is located at 6949 Thomas Boulevard. Built at the turn of the 20th century, the homes were part of what was to be a more extensive suburban development. The original plan included all the land between North Dallas Avenue and North Murtland Street, from the Pennsylvania Railroad tracks to Penn Avenue. Most of the structures in these parameters were built by 1923. (SLL.)

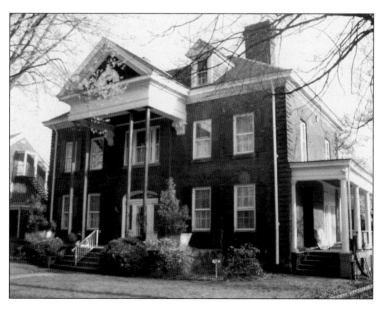

The last existing structure of the famed Westinghouse Park Plan is this home at 6959 Thomas Boulevard, bordering Westinghouse Park. A sixth house near the corner of Thomas Boulevard and North Murtland Street, indicated as the J.H. Hunter house on the 1923 Hopkins Plat Map, has since been demolished. (SLL.)

Famed actress Lillian Russell lived a block from where this image of Thomas Boulevard and North Linden Avenue was taken from the corner of Penn and North Linden Avenues, with a view looking south. Russell was known for her stage presence, voice, and hourglass figure. She began her career in New York City as a member of the chorus for Gilbert and Sullivan's *HMS Pinafore* in 1879, which catapulted her to fame as the foremost singer of operetta stage roles. She also had a number of romances, including with "Diamond Jim" Brady, who showered her with diamond gifts and supported her extravagant lifestyle. (AGS.)

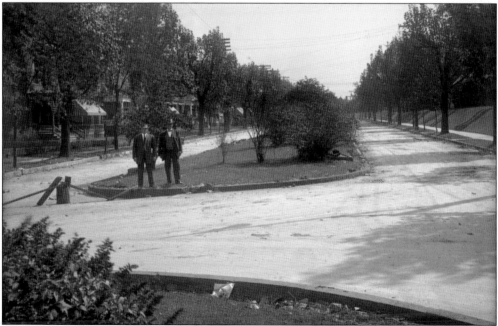

Russell married her fourth husband, newspaper magnate Alexander Pollock Moore, at the Schenley Hotel (the University of Pittsburgh's Student Union) and retired from her four-decades-long career. At the time of her death, Russell had become an ardent support of the women's suffrage movement and completed a fact-finding mission on immigration for President Harding. At the age of 61, she died at her North Point Breeze home on June 6, 1922. (ASC.)

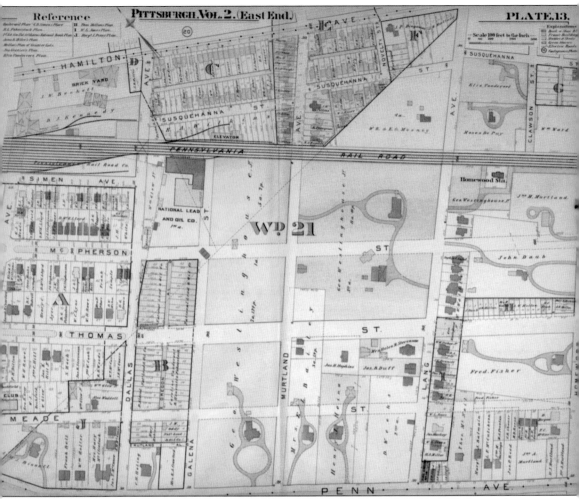

The G.M. Hopkins plat map of 1899 displays North Point Breeze's growth and diversity during Pittsburgh's Gilded Age. George Westinghouse's estate dominates the area, with H.J. Heinz's estate in evidence on Penn Avenue. John Murtland's estate, Chester Manor, is still located near the Homewood Station (as seen on page 14). Engine House No. 16 has just been built, and the grassy islands of the Boulevard Park Plans are seen on Thomas and McPherson Boulevards. Meade Street does not go all the way through due to the Westinghouse and Heinz estates. Oregon Street is now recognized as an alley. But Galena Street would disappear in the next century. By 1904, the DCA club would become the location of the East Liberty Academy. The D.J. Kennedy Coke Company expanded its reach from Braddock Avenue and Thomas Boulevard to the railroad tracks parallel to Simen Avenue. (ASC.)

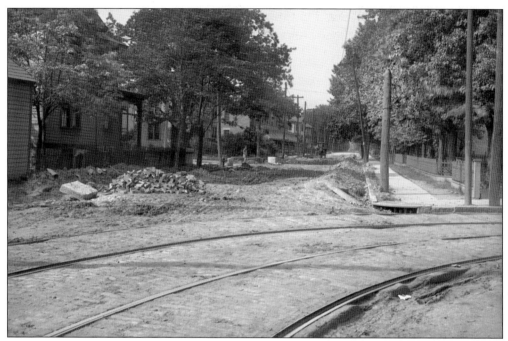

Taken at Peebles and Edgerton Streets on June 21, 1910, this image depicts what was happening to many city streets as the automobile became the mode of transportation. This glass-plate negative print shows Pittsburgh's efforts to document repaved city streets. Trolley tracks are shown in the foreground; the workman and his presumed horse and wagon are in the background. (ASC.)

Other examples of these Edwardian "railroad" apartments in North Point Breeze include the Cornell and the Marie apartment buildings on Thomas Boulevard. After the demise of both the Boulevard and Westinghouse Park Plans, the Cornell and the Marie offered another housing option, as families in the 20th century became smaller. (SLL.)

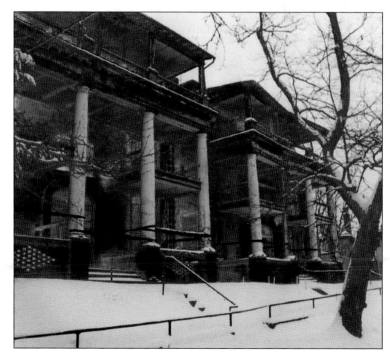

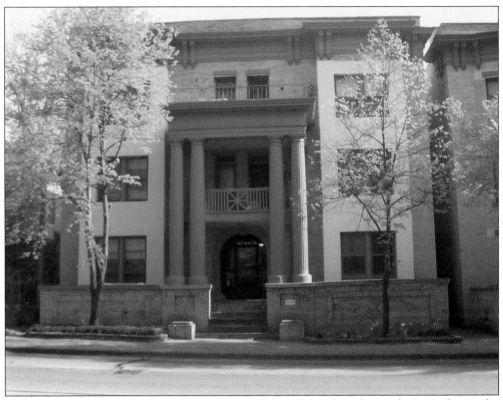

Prime examples of the Edwardian apartment-building style, with multitiered portico fronts, the Argyle (pictured), Lexington, and Drexel apartments became popular as families became smaller and more transient. As large estates grew out of fashion, the Point Breeze neighborhood changed with the advent of smaller homes and apartment buildings. (SLL.)

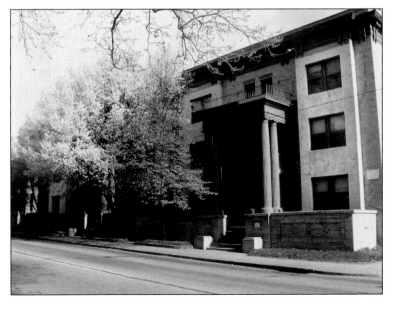

The Argyle, Lexington, and later, Drexel apartment buildings located in the 7200 block of Penn Avenue offered another housing alternative to larger homes. These Edwardian apartment buildings are located across from both H.C. Frick's home, Clayton, and small businesses on the south side of Penn Avenue. (SLL.)

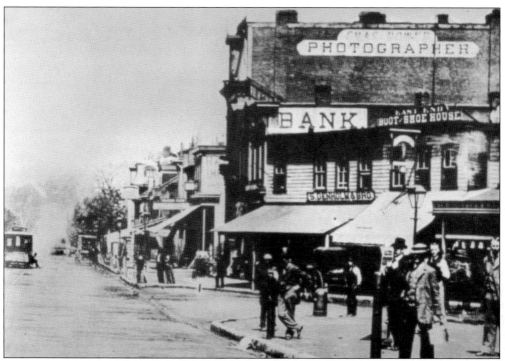

From log cabins that dotted early East Liberty to the hotels and taverns that served travelers along the Greensburg Pike, commerce flourished west and north of the Point Breeze neighborhood. But services changed, as did the needs of Point Breeze residents. (AGS.)

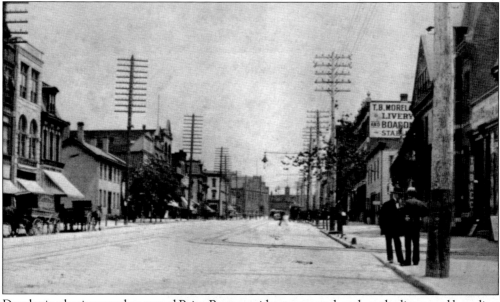

Developing businesses that served Point Breeze residents emerged, such as the livery and boarding stable seen on the right. The proprietor also served as the mortician to many of Point Breeze's families. Once merchants became mobile, Point Breeze residents enjoyed daily visits from the milkman, iceman, and vegetable huckster. Traveling by horse and buggy, the scissor sharpener and umbrella man made daily calls as well. (AGS.)

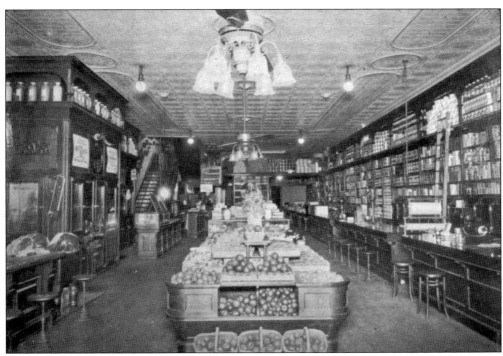

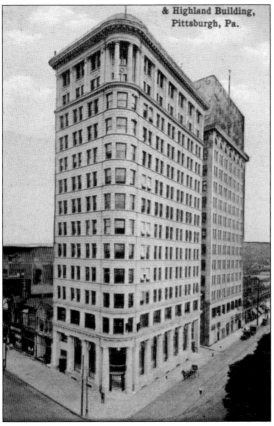

& Highland Building, Pittsburgh, Pa.

In the historic Stevenson Building on the corner of what is now Center Avenue and South Highland, Kuhn's Grocery stocked many of the pantries in Point Breeze. The grocer, George K. Stevenson, would ring up Point Breeze residences daily, speaking directly to housewives or house staffs. After getting a list of grocery items that each individual home needed, Stevenson would deliver the items to its door. (AGS.)

Once one of the tallest buildings in East Liberty, the East End Savings and Trust Company no longer exists. But in its heyday, the building was a skyscraper marvel in addition to a center of commerce. In recent years, the Highland Building, in the same vicinity as that of the East End Savings and Trust Company, has been considered for an urban residential project. (AGS.)

Four

HOUSES FOR SALE

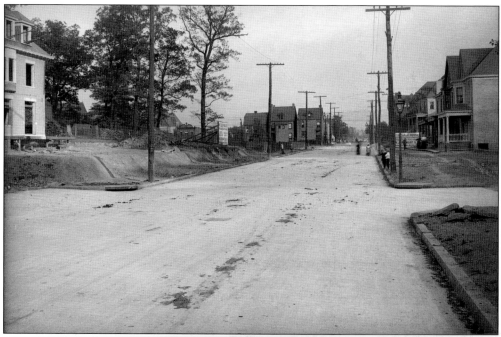

This highly traveled corner of Reynolds and South Murtland Streets shows its 20th-century beginnings, with new sewer lines, sidewalks, and houses. The billboards on either side feature advertisements for W.J. Stewart & Company. In addition to the headline "Will Sell These Choice Lots," the billboard on the left side provides the lot sizes and building line measurements. On the right, the sign advertises, "For Sale, Houses / Lang, Reynolds, Lloyd & Edgerton Streets / Alter to Suit Purchaser." (ASC.)

The building on the left has been a mom-and-pop grocery store for the last 67 years. Presently, it is the home of Frick Park Market, which has occupied this site since 1942. Prior to that, the building housed the Lang Drug Store in the 1920s and early 1930s. A Great Atlantic & Pacific Tea Co. (A&P) store occupied the space for four or five years in the latter part of the 1930s. At one time, A&P stores was the largest grocery store chain in the country. (ASC.)

An example of the many local grocery stores in the neighborhood, the S.B. Charters Grocery Company on South Linden Avenue was one of nine area locations, with the company's main headquarters on Grant Street in downtown Pittsburgh. This image shows store number nine on January 24, 1921. Ron Fuchs, of the legendary Frick Park Market, remarked that his father, Lou, also worked as a butcher for the S.B. Charters Grocery Company. (ASC.)

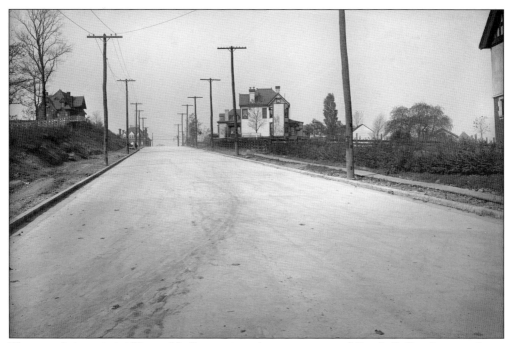

The west-facing view of Reynolds Street, near the intersection of South Dallas Avenue, shows the relative simplicity of homes and land in Point Breeze. Newly placed poles carrying electricity per George Westinghouse and Nikola Tesla's alternating current system dot the sparse landscape of houses and pastures. (ASC.)

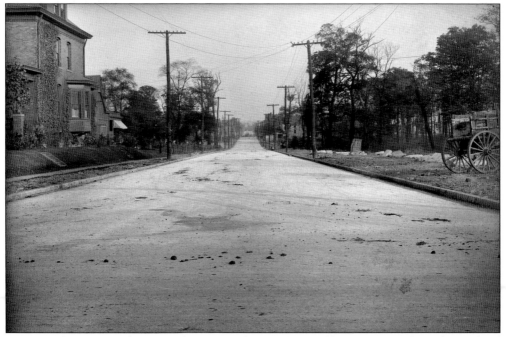

Facing in the opposite direction, this eastward view of Reynolds Street toward South Murtland Street reveals how the Point Breeze neighborhood was in transition. The house on the left corner still exists. Many of the pastures, however, have been converted to residential lots. (ASC.)

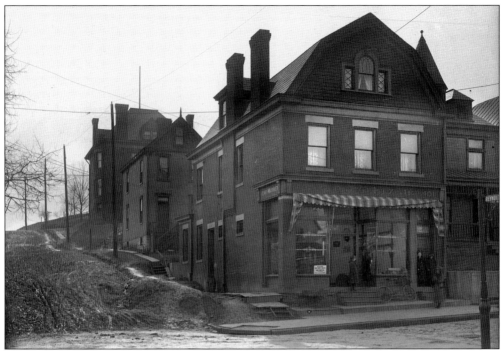

This popular corner of "downtown" Point Breeze began its early commerce days as a meat market. The proprietor's name, "Geo. [George] J. Geltz Jr.," was emblazoned on the storefront, along with "Meat Market" on the Reynolds Street side. In later years, Senator's, a popular Point Breeze restaurant, was located on this corner. It is now the home of the equally popular Point Brugge Café. (ASC.)

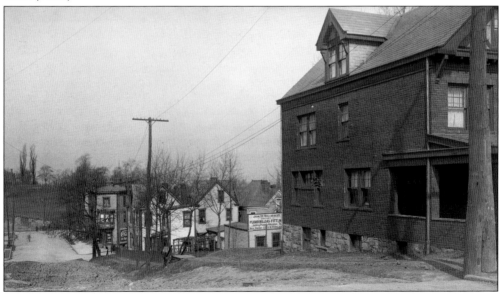

With Lyndhurst looming on the hilltop in the distance, this downhill view from the corner of Linden Avenue and Reynolds Street reveals the small Point Breeze business district, including the Joseph H. Burke "Sanitary" Plumbing & Gas Fitting company, as seen on the large sign at center. Another sign over the left window frame identifies Burke as a "Registered Plumber." (ASC.)

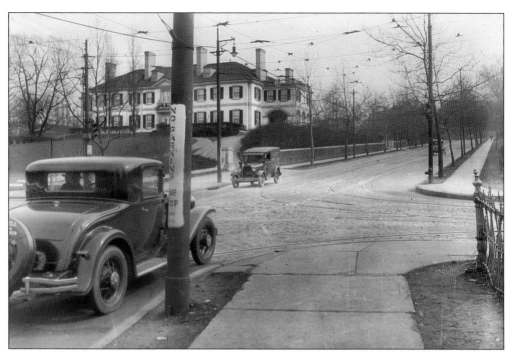

The Marshall house dominates the background of this image taken on March 30, 1933. At this busy intersection of Fifth and Shady Avenues, automobiles are becoming the preferred mode of transportation. The Marshall mansion was spared from being razed when it found a new life as the Pittsburgh Center for the Arts. (AGS.)

Copy from this advertisement for Homewood Cemetery in the c. 1900 Diffenbacher's directory illustrates how illustrious it was to be buried in the cemetery—as well as being peaceful and serene: "A secluded and beautiful situation, convenient of access; but from its location, peculiarly free from the noise, dust and smoke of the city. From the high and rolling character of the surrounding country, it is not likely ever to be closely surrounded, or nearly approached by manufacturing establishments; rendering it a most desirable locality for the peaceful city of the dead." (FF.)

HOMEWOOD
Cemetery

Pittsburgh's Illustrious
"City of the Dead"

BY
EDWARD M. POWER

FORBES STREET ENTRANCE

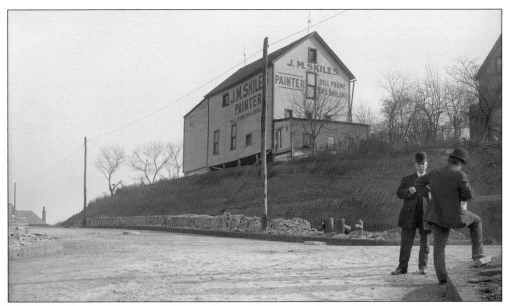

This image depicts the corner of Gettysburg and Edgerton Streets. The signage for painter J.M. Skiles prominently displays his contact information: "Bell Phone Number 904-J.Highland." In addition to plumbing businesses and small grocery stores, Skiles's local painting company thrived in the predominantly residential Point Breeze neighborhood. Residents had busy Penn Avenue businesses to accommodate their larger household needs, as well as traveling merchants selling their wares. Note the gentleman facing the camera; he also appears in the center of the images found on page 63. (ASC.)

Taken in June 1909, this construction image of the area near Gettysburg and Edgerton Streets shows how remote and rural parts of the Point Breeze landscape still were at the start of the 20th century. The same building advertising "J.M. Skiles, Painter" is seen at left on the hill. It is unknown if the house to the right was Skiles's residence. (ASC.)

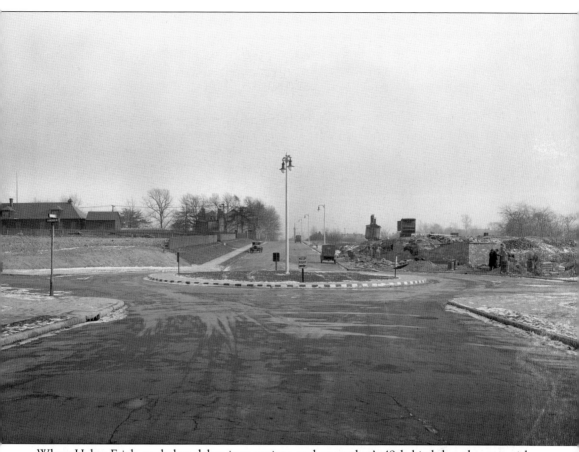

When Helen Frick made her debut into society on her mother's 49th birthday, the one wish she asked her father to grant was to build a park where the children of Pittsburgh could enjoy nature. It is unknown whether this wish actually inspired Frick Park. But when he died, Henry Clay Frick bequeathed 151 acres to the City of Pittsburgh with the edict that the land become a city park. Frick also provided a $2 million trust to maintain and develop the park along the same lines as Schenley and Highland Parks. In December 1934, the familiar entrance to Frick Park was constructed at the intersection of Reynolds Street and Homewood Avenue. Helen Frick commissioned Beaux-Arts master John Russell Pope to build impressive park entrances at Reynolds Street, Beechwood Boulevard, and Forbes Avenue. Pope worked with the noted landscape architecture firm of Innocenti & Webel from 1931 to 1935. Until 1957, Innocenti & Webel continued to create more trails, as well as the designation of green spaces and plantings. The Point Breeze entrance remains to greet residents enjoying Frick Park today. (AGS.)

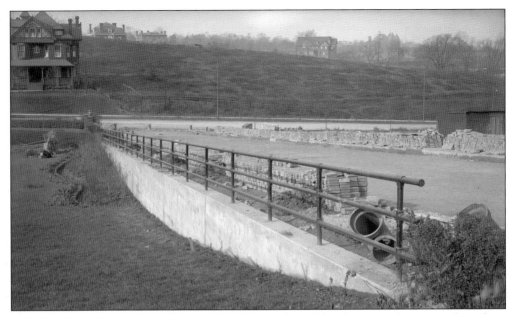

Taken on November 12, 1909, during an age of growth and development, this image shows how the rural landscape was rapidly transforming. This view looking toward Beechwood Boulevard features a retaining wall at the intersection of Gettysburg Street at Fair Oaks. The photograph is part of the Pittsburgh City Collection. (ASC.)

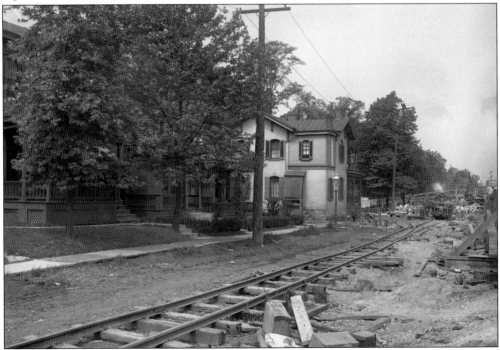

Jonathan Street parallels the railroad tracks at Homewood Station. Here, workers are tearing down or replacing the platform for the station while a Jonathan Street resident's clean laundry dries on a nearby clothesline. The view in this image, taken on May 26, 1913, looks west at the corner of Homewood Avenue. (ASC.)

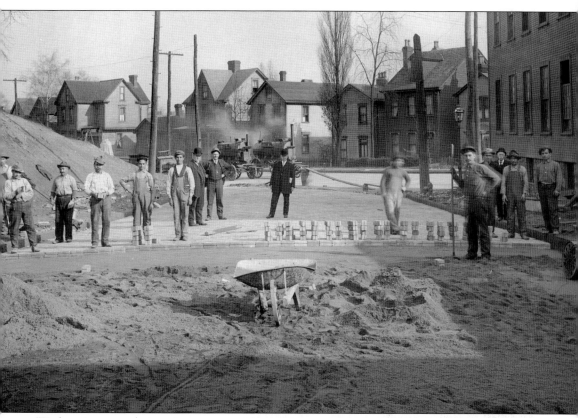

Workers interrupt their project to pose with machines on Gettysburg Street, near the intersection with Reynolds Street. According to a conversation with the Fields family, the houses in the background were at one time owned by the Thaw family. The Thaw family servants, who were usually Irish immigrants, resided in these structures, which were in proximity to their employer's castle-like mansion, Lyndhurst, at the top of the hill. (ASC.)

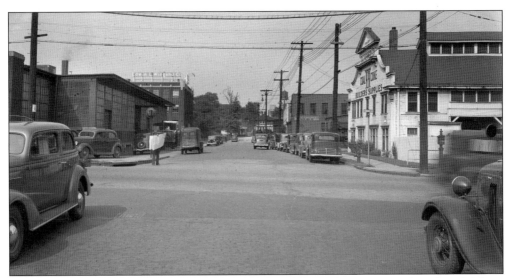

Another natural intersection for traffic, Braddock and Penn Avenues served as thoroughfares for businesses. The D.J. Kennedy Company provided coal, coke, and builders' supplies, including sewer pipes, roofing material, face brick, cement, and lime. Other companies of note include Mine Safety Appliance Company (MSA), Rockwell International, Grennan Bakeries, and Pittsburgh Motor Car Company, among others. (ASC.)

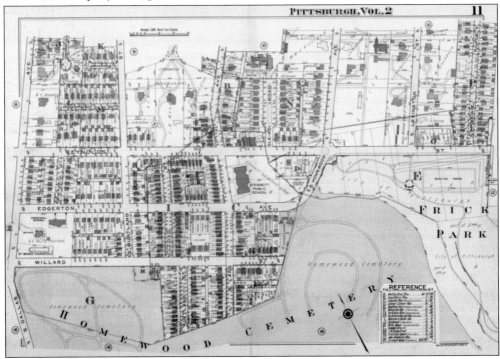

This 1939 plat map documents the neighborhood's growth. New neighbors like the New Church Corporation of Pittsburgh had been in place by the 1930s, when the corporation (Pittsburgh New Church, or Swedenborgian Church) bought part of the Curry estate. The Pittsburgh New Church School originated on Wallingford Street in Shadyside, but it moved to a new campus in 1930. (ASC.)

This scene shows the intersection of Penn and Fifth Avenues in 1927 and includes both automobiles and a horse-drawn wagon. In the background is the National Biscuit Company. The traffic marker in the middle of the intersection directs drivers from "Fifth Avenue to Butler," with an arrow underneath. The Point Breeze Presbyterian Church proclaims "All Welcome" in its announcement sign, while the Chevrolet billboard above proudly advertises "Amazing Quality." (ASC.)

Looking south toward the stately mansions that existed in 1927, this view in the opposite direction shows Penn Avenue east of the intersection with Fifth Avenue. (ASC.)

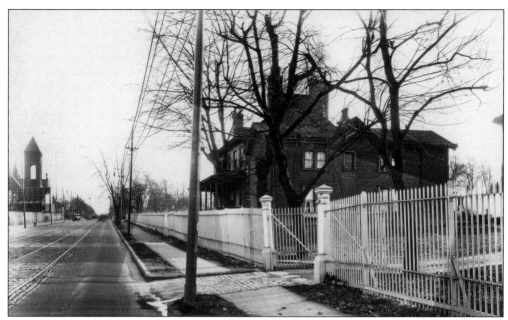

Few changes have been made to the Presbyterian church's original building at left in the background. It is reported that, during the 1940s, the high steeple of the church was struck by lightning, with bricks falling to the surrounding sidewalks. Consequently, the steeple was lowered considerably when it was rebuilt. The tower includes two classrooms whose windows are seen in exterior photographs of the church. (ASC.)

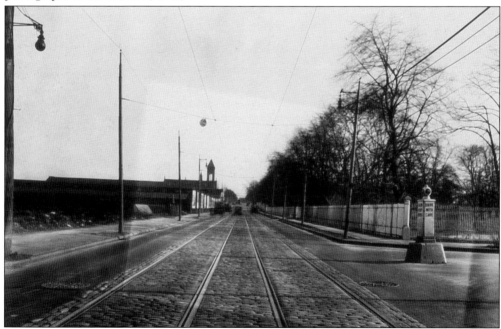

Further west on Penn Avenue, the cobblestone-lined trolley tracks are prominently displayed, with a "Car Stop" warning sign above and a 1920s traffic light cautioning motorists to "Drive With Care" at right. The Point Breeze Presbyterian Church's silhouette can be seen in the distance at Fifth and Penn Avenues. (AGS.)

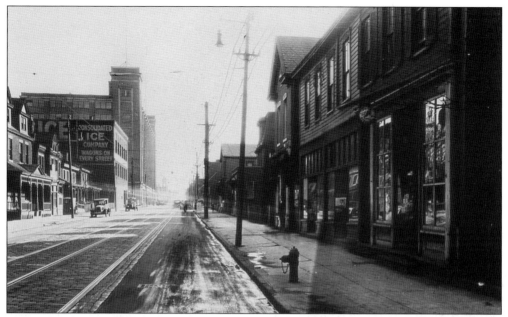

This photograph of the bustling business district west of the intersection of Penn and Fifth Avenues was taken in 1927. The cattle lots and warehouses of the late 1800s have been replaced with small businesses and homes, with the exception of the Consolidated Ice Company, which advertises "Wagons On Every Street" on its facade, next to the tower of the iconic National Biscuit Company (Nabisco). (AGS.)

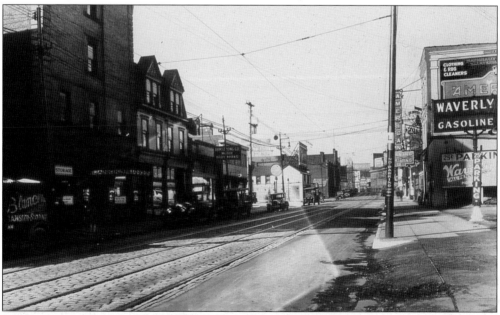

Taken in 1927, this busy commercial street scene along Penn Avenue shows a thriving Pittsburgh. With more automobiles, gas stations like the Waverly dotted city streets. Armstrong Company Motor Body Works provided the necessary maintenance and repair automobiles required. Along with the automobile came a more transient population, as evidenced by the transfer and storage company across the street. (AGS.)

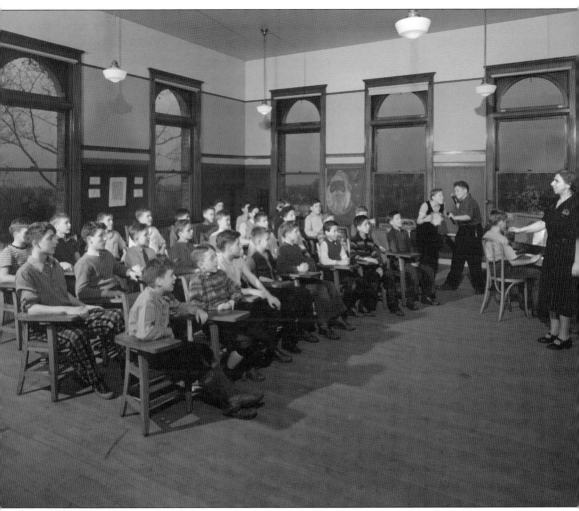

Named for the street on which it was located in Pittsburgh's Point Breeze neighborhood, the Linden School was constructed in 1903 to accommodate the growing student population. It was one of few schools in the Pittsburgh Public School system that was equipped with an in-house generator to supply electricity for lighting in the building. In 1908, Linden was the first school in Pittsburgh to start a school garden. In 1927, a new addition, designed by local architect Thomas Pringle, was built to house eight classrooms and an auditorium. A classroom for gifted students at the Linden Elementary School is featured in this c. 1939 image. Author and Pittsburgh native David McCullough lived on Glen Arden Drive while attending the Linden School. Current chief operations officer for the City of Pittsburgh, Guy Costa is another famous alumnus of the school. (HHC.)

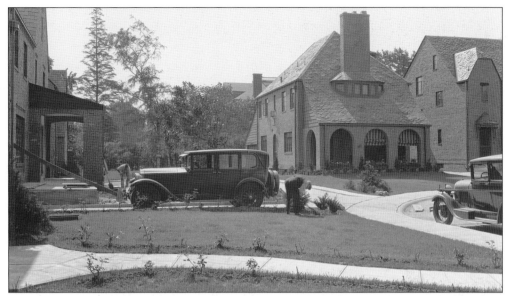

Newly created Yorkshire Drive demonstrates the trend toward smaller homes in the urban suburbs established on the former estates of Point Breeze. Taken on June 12, 1931, this image displays the newer cul-de-sac. In the background, a larger, older home, though not the size of a mansion, contrasts the progression from larger to smaller homes as family size and needs changed throughout the 20th century. (ASC.)

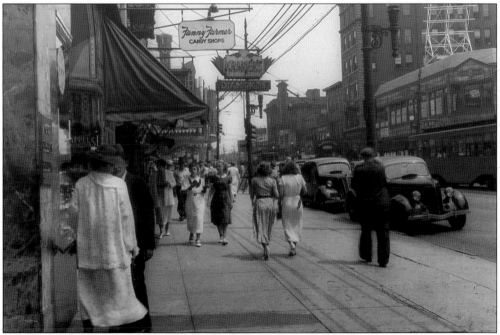

This street scene of Penn Avenue west of Fifth Avenue from July 20, 1937, reveals how dynamic and thriving the business center became after World War I. East Liberty competed with Pittsburgh's downtown area as a place of business and on Friday and Saturday evenings for date nights. Not too far away, the Penn Avenue portion of Point Breeze offered more family-related alternatives like walkable grocery stores and roller-skating rinks. (AGS.)

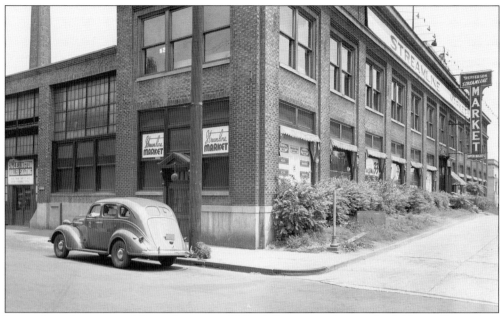

Located on the corner of Penn Avenue and North Lexington Street, the Jefferson Streamline Market, which was also open nights, was a cornerstone of the busy business district and a community resource for Point Breeze in the 1930s. Around the corner from the market was a popular neighborhood favorite, the Lexington Roller-Skating Rink. The Frick mansion, Clayton, is still across the street, as is the Evergreen Café. (ASC.)

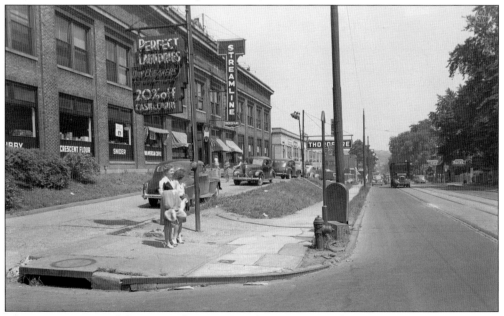

This exterior view of the Streamline Market shows an active business district at Penn and North Lexington Avenues on a summer day in July 25, 1937. The Manor Hotel's sign advertising available rooms can be seen at right in the distance, along with additional signs pertaining to "Tourists" in front. Next door, the Evergreen Café caters to its lunch crowd, and seen beyond that is a drugstore. (ASC.)

Five

BUCOLIC LIFE

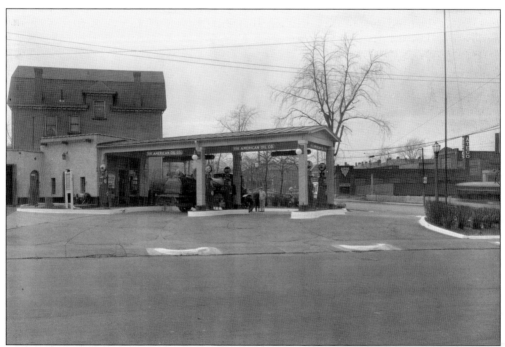

As an example of the many city service stations, this image shows the busy corner of South Braddock and Penn Avenues on April 5, 1932. Gasoline stations serviced the automobiles of the day, including many that were built in Pittsburgh car companies on Center Avenue and the surrounding area. According to the Frick Car and Carriage Museum, there were more than 30 automobile manufacturing companies within a seven-mile radius at the turn of the last century east of Point Breeze. (ASC.)

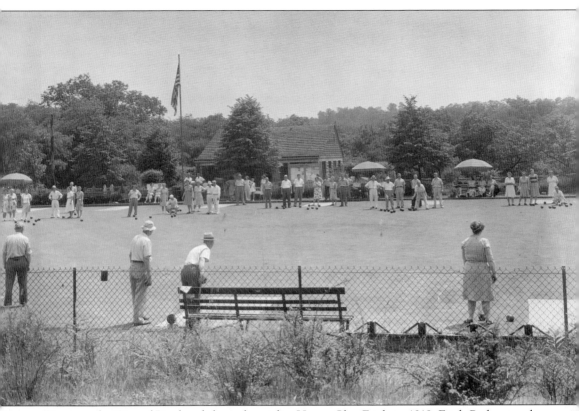

Given to the City of Pittsburgh by industrialist Henry Clay Frick in 1919, Frick Park extends into a small, level portion adjacent to the Frick estate. It was determined that this section of the park would be an ideal location for some type of recreational activity that would be popular among residents while at the same time be of value in beautifying and enhancing the landscape. After considerable discussion and research, the Frick Park Bowling Green was planned, and in 1935, construction was started with general grading, drainage, and other preparatory work. The following year, the seedbed was prepared and nurtured through 1937. The first game was played in the afternoon of Saturday, May 15, 1938. At the time, the club had 33 members under the leadership of John H. Elliot, the first president. Membership quickly increased in the first year and subsequently thereafter. By 1939, the club had 139 members. Women were always an important part of the organization—although, in the early years, men and women bowled in separate leagues. (FPBLC.)

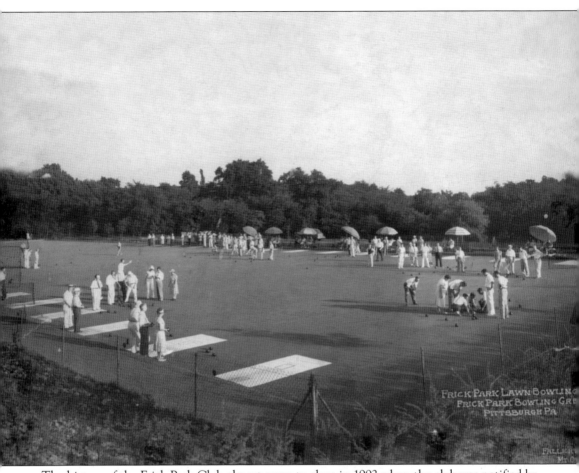

The history of the Frick Park Club almost came to close in 1992 when the club was notified by the City of Pittsburgh that it could no longer afford the bowling green and planned to convert it to a grassy park area. Through the dedicated leadership of then president Eileen Luba, the club requested and accepted a role as "Partners in Parks" in which the Frick Park Club pledged to the city that it would assume all costs of maintaining the greens in exchange for the city's promise to keep them intact. Dues were increased, fundraising activities started, and donations were requested. Equipment had to be purchased, a competent greenskeeper had to be hired, and many problems had to be solved. The dedication and hard work of club members has paid off, and the greens are now in excellent condition. According to member James Cunningham, "We sincerely hope that we will be able to keep this wonderful sport alive in Pittsburgh for many years to come." (FPLBC.)

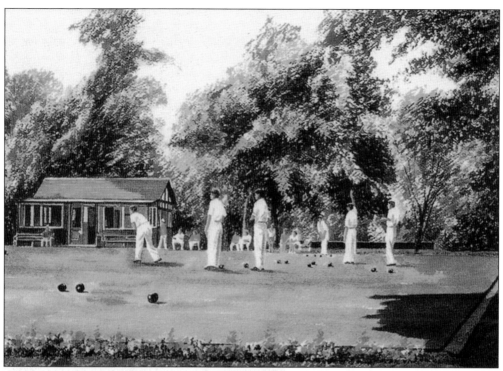

Built under a contract with the National Youth Administration, the clubhouse was added in 1940. Lights for evening bowling were added in the 1950s. Originally, there were three playing fields, but the third field was eliminated because it proved too costly to maintain, according to the late, great H.J. "Hank" Luba, longtime lawn bowling enthusiast from 1982 and the heartbeat of the Frick Park Lawn Bowling Club. (FPLBC.)

Luba and his wife, Eileen, held numerous positions within the club. The Frick Park Lawn Bowling Club is the only public organization of its kind in the commonwealth of Pennsylvania. Games and practices are ongoing events each spring, summer, and fall, and membership is as strong as when the club was first organized in 1939. (FPLBC.)

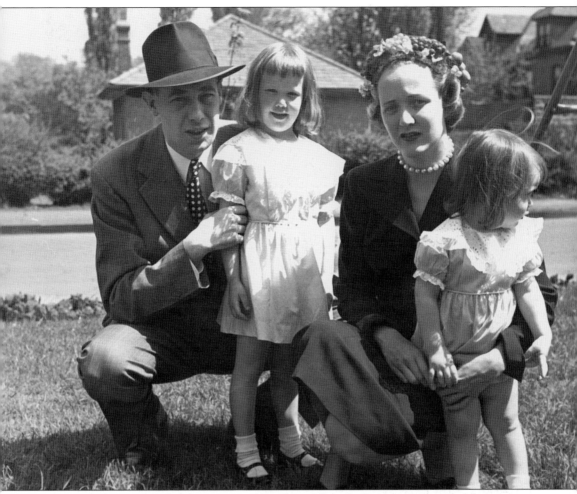

This enchanting 1949 family portrait of Frank and Pamela Doak and their daughters, Annie (left) and Amy, was taken on a sunny Easter Sunday at author Annie Dillard's first childhood home at the corner of Edgerton and South Murtland Streets. Dillard popularizes the Point Breeze neighborhood in her novel *An American Childhood*: "In fact, they were young. Mother was twenty-two when I was born, and Father twenty-nine; both appeared to other adults much younger than they were. They were a handsome couple. I felt it overwhelmingly when they dressed for occasions." (ADF.)

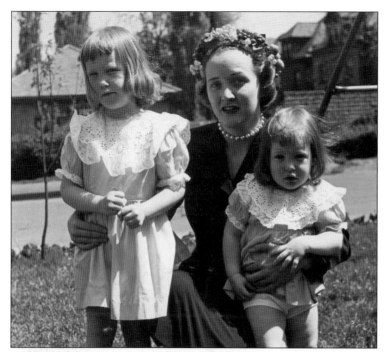

Like most young children, Annie was in awe of her mother's beauty—especially when her mother dressed up for occasions such as Easter Sunday: "I never lost a wondering awe at the transformation of an everyday, tender, nap-creased mother into an exalted and dazzling beauty who chatted with me as she dressed. Her blue eyes shone and caught the light, and so did the platinum waves in her hair and the pearls at her ears and throat." (ADF.)

Fathers were no exception to their young children's admiration either. In her novel *An American Childhood*, Annie Dillard remarks that "Father's enormousness was an everyday, stunning fact; he was taller than everyone else. He was neither thin not stout; his torso was supple, his long legs nimble." Dillard won a Pulitzer Prize for General Nonfiction in 1975 for *Pilgrim at Tinker Creek*. (ADF.)

Mother and daughter Annie often roller-skated on Point Breeze streets. This image captured the pair on South Murtland Street. In an interview with Ron and Bob Fuchs, the brothers commented that Pam Doak and her daughter would roller-skate to their parents' market on South Reynolds Street. (ADF.)

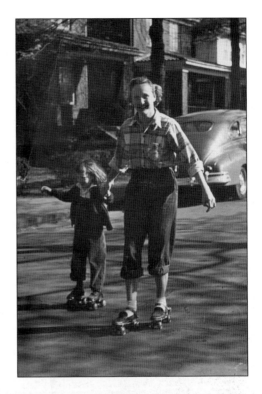

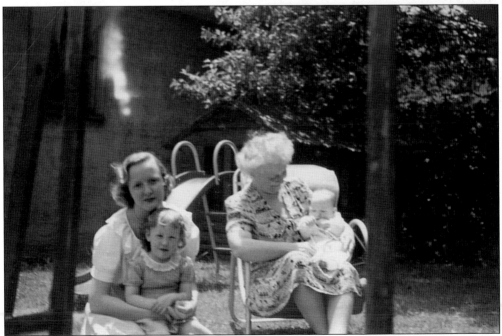

This delightful image shows Pamela Doak and daughter Annie seated in her lap on the left, while the girls' maternal grandmother holds Pam's younger daughter, Amy, on the right. The photograph was taken in the backyard of the girls' first home at Edgerton and South Murtland Streets. (ADF.)

Young Annie deftly handles a saw, oblivious to infant sister Amy's crying in the background. *An American Childhood* notes: "As a tomboy full of athletic energy and eagerness, (Annie) Dillard avidly claimed her territory: pelting cars with snowballs, joining boys' sandlot baseball games, roaming Frick Park by herself, though her father tells her not to because of 'bums lived there under the bridges.'" (ADF.)

The house was flanked by two young trees that were planted while the Doak family resided there. One of the trees was nicked by a lawn mower and split. Both trees are still in existence today. In *An American Childhood*, Dillard recalls that "Oma's chauffeur, Henry Watson, dug a hole in our yard on Edgerton Avenue to plant a maple tree when I was born, and again when Amy was born three years later." (ADF.)

A very young Annie Dillard is photographed on her tricycle on a Point Breeze street near her home. She later wrote: "I had been born at the end of April 1945, on the day Hitler died; Roosevelt had died eighteen days before." (ADF.)

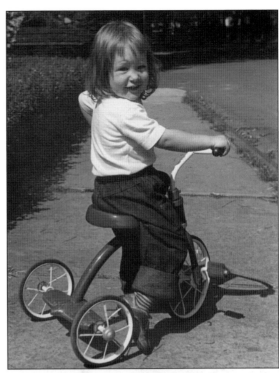

"The war was over. People wanted to settle down, apparently, and calmly blow their way our of years of rationing. They wanted to bake sugary cakes, burn gas, go to church together, get rich, and make babies," reads an excerpt from *An American Childhood* by Annie Dillard.

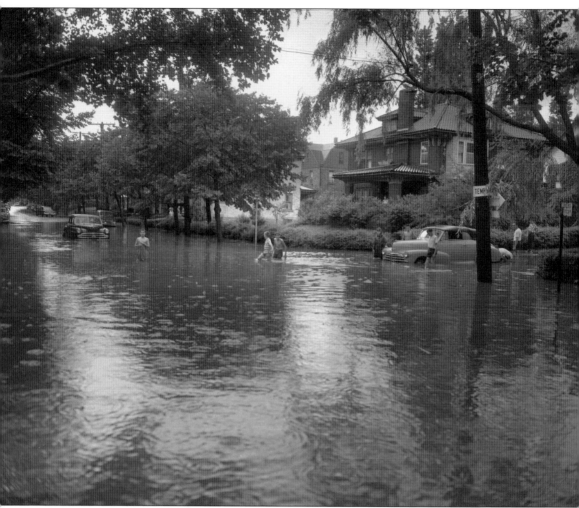

This view of children wading in the floodwaters at the corner of Reynolds and South Murtland Streets in 1950 is reminiscent of a similar rainstorm that resulted in the same waist-high water in the summer of 2009—almost 60 years later. In earlier maps, a small creek existed at the start of what is now Homewood Cemetery and South Homewood Street, with a bridge spanning across, according to Ron and Bob Fuchs of Frick Park Market fame. The creek would overspill its banks travel along Reynolds Street when heavy rains came, as in 1950 and 2009. (ASC.)

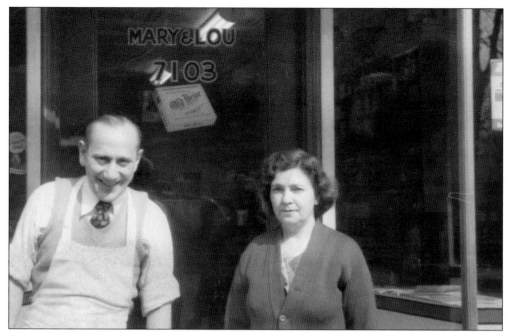

Ron and Bob Fuchs's parents, Louis and Mary, ran the Frick Park Market since 1942. "My father was the hardworking German, and my mother was the brains," remarked Bob Fuchs in a recent interview. "Whatever the customer wanted, we gave them." This image of the couple shows them during their first year of business. (FF.)

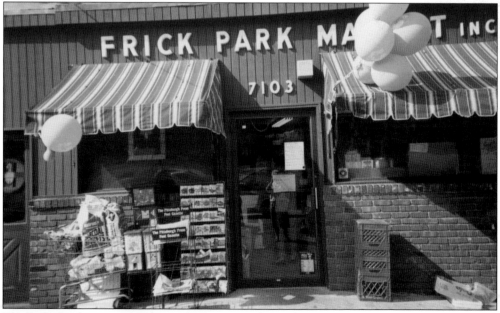

The Fuchs brothers recounted countless stories, including how one customer wanted her Christmas tree delivered on Christmas Eve so as not to ruin the surprise of the tree for her children. When another customer's dog died, she called the store to have the young Fuchs boys come to her home and bury the dog. The Frick Park Market storefront has not changed much since the time Pittsburgh had two newspapers. (FF.)

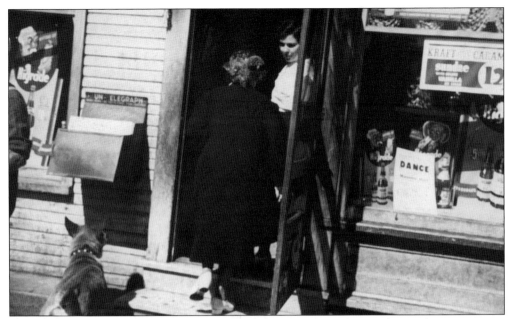

Mary Fuchs is seen welcoming a customer, and probably a friend, into the confectionary store next to her tearoom. The store sold soft drinks, lemonade, ice cream, and other treats, as seen by the advertisements in the window. Based on the announcement for an upcoming dance displayed in the window, the combination store, market, and beer/tearoom was also a hub of social activity. (FF.)

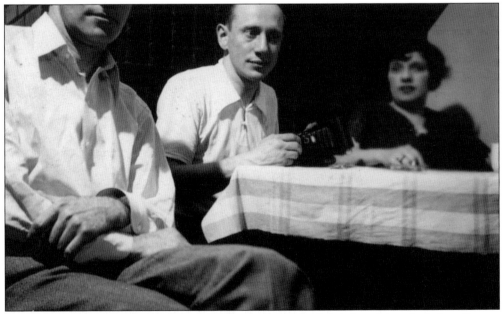

In addition to running the Frick Park Market with her husband, Lou, Mary had the adjacent tearoom, where people would socialize in the evening. Lou (center) and Mary Fuchs are seen here with their friend John Murphy (left). During World War II, the tearoom served as a circulation hub, forwarding letters from soldiers who did not know where their friends were stationed or writing to the boys from the neighborhood who had gone into the service. (FF.)

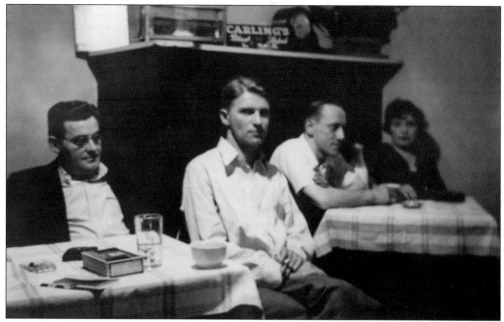

The tearoom was known by several names—Mary's Tea Garden, Mary's Tea Room and Social Club, and Fuchs Emporium. Gathered in the tearoom at 7113 Reynolds Street in the Point Breeze neighborhood are, from left to right, the Fuchs' friends Gene Lieber and John Murphy, along with Lou and Mary. The land where Lang Court is located was used to plant victory gardens during wartime. Victory gardens were vegetable and/or fruit gardens planted during both world wars to compensate for food rationing due to the war effort. (FF.)

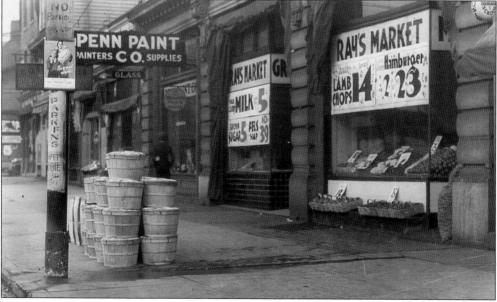

This Penn Avenue image from the 1930s depicts the bustling business center that was East Liberty. A sign on the lamppost at left implores people to "be a good neighbor" by contributing to the Community Fund. All the businesses have changed or closed over time, further emphasizing the strength of the Point Breeze neighborhood and Frick Park Market. (AGS.)

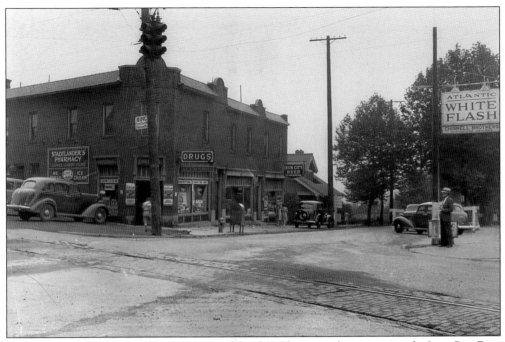

In this image taken on October 6, 1936, Stadtlander's Pharmacy features a sign for Iron City Beer on its facade, and across the street is the prominent sign for Atlantic White Flash. This particular drugstore, seen in this view looking west from Verona Road, was located on Frankstown Avenue, but others just like it dotted the landscape, similar to today's convenience stores. Akin to the Frick Park Market, Mary's Confectionary, and the tearoom, these stores also served as neighborhood hubs for socialization and information. (AGS.)

A.M. Trench (Mike Trench), author of *A Florida Triptych* and boyhood friend of Ron Fuchs, is featured in this endearing photograph taken in front of the Sterrett School at the corner of South Lang and Reynolds Streets. (FF.)

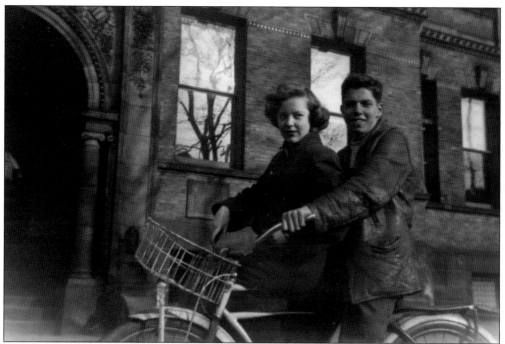

Affectionately known as "Sugar," Betty Mader shares a bicycle ride with admirer Ron Fuchs in front of the Sterrett School in their Point Breeze neighborhood. Ron and his brother Robert worked at the nearby Frick Park Market with their parents, Louis and Mary, for many years. (FF.)

Taken on Easter of 1951, this image captures, from left to right, Betty Mader, Ron Fuchs, Peggy Williams, and Kitty Lou Phillips. The foursome's photograph was taken in front of the garages for the Frick Park Market. (FF.)

A dapper Robert "Bobby" Fuchs flaunts his finest Easter attire in this photograph taken on March 25, 1951. Lou and Mary Fuchs had three sons—Louis "Dickie" Fuchs, born in December 1932; Robert Rudolf Fuchs, born in July 1943; and Ronald Gilbert Fuchs, born in March 1936. At the age of 12, Dickie died as a result of leukemia in 1944. (FF.)

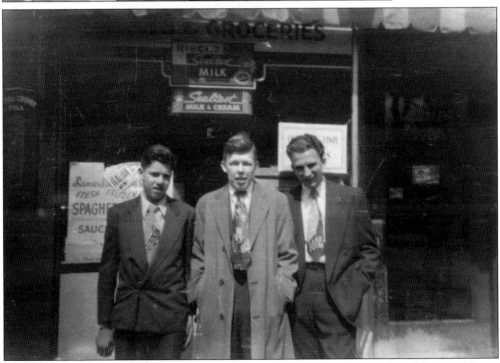

A younger Ron Fuchs (left) and boyhood buddies Eddie Hasky (center) and Roy Fields are pictured on Easter Sunday 1950 in front of the Fuchs family's Frick Park Market. At the time of this photograph, the store is advertising "fresh, frozen spaghetti sauce" as well as Royal Crown Cola and Riech's Sealtest Milk and Cream. (FF.)

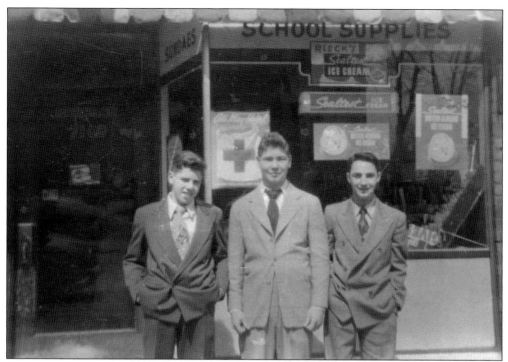

This trio includes, from left to right, Ron Fuchs, Ray Muehl, and Nick Greisinger, who are also pictured on Easter Sunday 1950. Inscribed on the window of the door at left is "Mary & Lou," along with the Frick Park Market address, "7103," underneath it. The store sold a variety of items, from school supplies to sundaes. (FF.)

This endearing photograph portrays the innocence of the times in the period following World War II. Bicycle riders Betty Mader and Ron Fuchs are pictured on the grounds of the Sterrett School. (FF.)

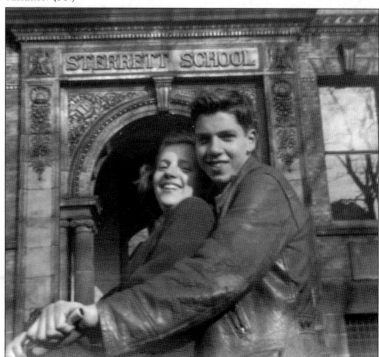

Louis (left), Robert (center), and Ronald Fuchs pose in their St. Joseph's Junior Military Academy school uniforms in 1943. A Catholic boarding school, St. Joseph's was located at 1725 Lincoln Avenue. Beginning in 1941, the boys attended the school for 10 years. (FF.)

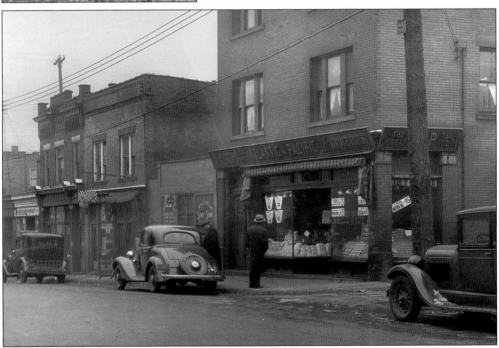

The Great Atlantic and Pacific Tea Co. (later known as A&P) was one of the larger and one of the first grocery store chains in the country. A&P stores competed directly with smaller family-run stores like the Frick Park Market and the S.B. Charters Company. Pictured on January 28, 1935, this A&P store was located on Frankstown Avenue, northeast from Brushton Avenue. (AGS.)

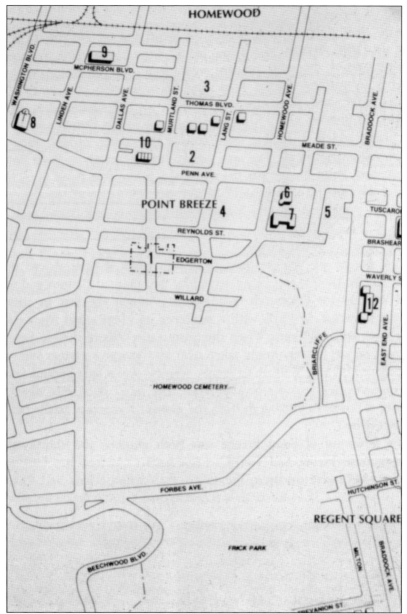

This map places some of the significant mansions that graced Point Breeze in reference to their locations among present-day streets. Judge Wilkins's Homewood, marked No. 1, was located near today's intersection of Reynolds and South Murtland Streets. H.J. Heinz's Greenlawn is identified as No. 2, at Penn Avenue and North Lang Street. Purchased in 1871, George Westinghouse's home, Solitude, stood on the grounds of what is now Westinghouse Park, with No. 3 marking its location on the map. No. 4 is Clayton, the former home of Henry Clay Frick, and it is the only house that remains today. Also noted is the Frick Art and Historical Center, which is No. 7 on Reynolds Street. Nos. 9 and 10 are the locations of Frederick Scheilber's Linwood apartment building on McPherson Boulevard and his Parkstone dwellings on Penn Avenue. Scheilber's Old Heidelberg apartment building is No. 12 on Braddock Avenue. Finally, the Point Breeze Presbyterian Church is marked as No. 8, where Washington Boulevard intersects Penn and Fifth Avenues. (AGS.)

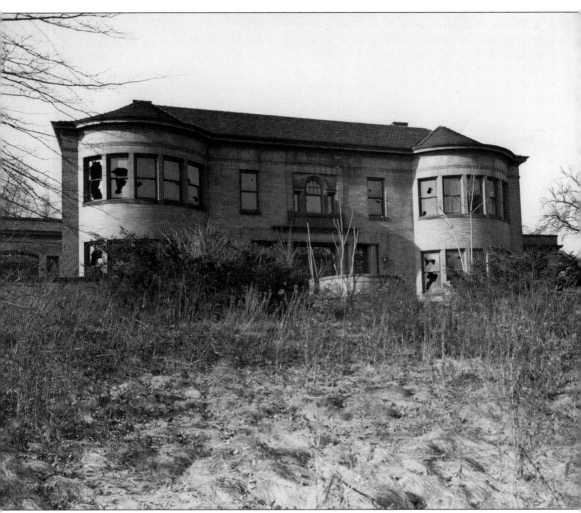

Taken on January 16, 1946, this photograph of the McClain mansion at 1160 Beechwood Boulevard is an example of the deteriorating conditions of most of the mansions on Pittsburgh's Millionaires' Row. As circumstances changed for wealthy families, many mansions were abandoned. In some cases, as family members died, those remaining could not maintain these enormous homes. Another scenario relates to the growing fortunes of wealthy families, as it was customary for them to move to larger urban areas, such as New York City, to compete both financially and socially with other affluent families. George Westinghouse's Solitude was sold to the City of Pittsburgh. Unfortunately, the city could not maintain the mansion, and it was eventually razed to the ground in an era before reusing materials came into vogue. It was more cost-effective for city officials to demolish the buildings instead of trying to preserve or maintain them. Only Clayton, along with its entire contents of furniture and personal effects, was saved, thanks to the preservation efforts of Helen Clay Frick. (HHC.)

Six

NORTH POINT BREEZE

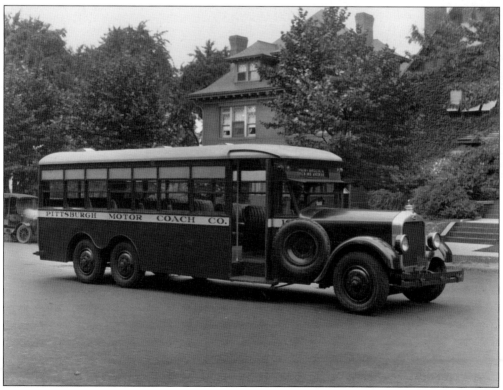

By the 1920s, the Pittsburgh Motor Coach Company was both a staple business and method of transportation in the eastern part of North Point Breeze and Pittsburgh. One of its motor coaches, seen here on North Lexington Street, had probably been dispatched from the headquarters at North Lexington Street and Thomas Boulevard. (NPBPDC.)

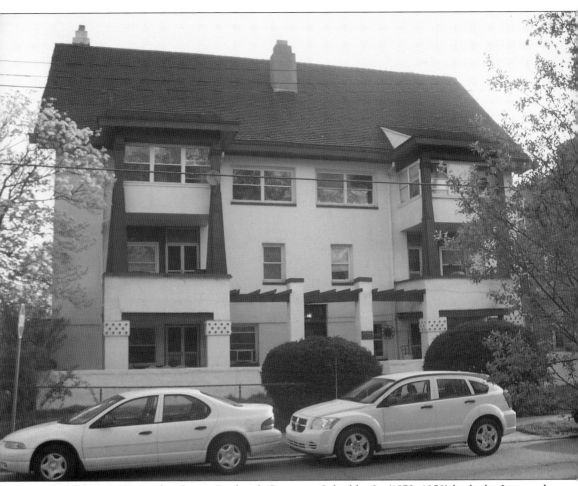

Pittsburgh native and architect Frederick Gustavus Scheibler Jr. (1872–1958) built the Linwood apartment buildings in 1906. Scheibler had apprenticed with Pittsburgh architectural firms, including Alden & Harlow, before opening his own office in about 1901. According to author and Carnegie Mellon University architecture librarian archivist Martin Aurand, "[Scheibler] developed a deep interest in the progressive European architectural movements of the turn of the century, and by 1905 was experimenting with forms inspired by the Arts and Crafts Movement, the English Free Style, the Viennese Secession and Art Nouveau. Although Scheibler has often been characterized as a modernist, and some of his works have strikingly modern qualities for their time, he is best understood as a progressive—an architect who attempted to restate traditional architectural ideas in a new and personal way." A leader in the progressive movement to improve housing for the working and middle class, Scheibler took inspiration from the Garden City Movement, which began in Great Britain. (SLL.)

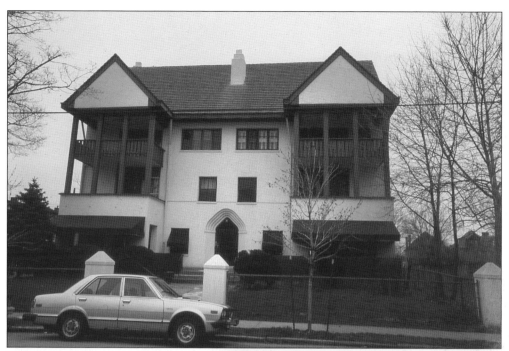

Built at the same time, the Linwood and Whitehall apartments have a T-shaped design consisting of six units with original stained-glass windows and tapered wood posts on the second-floor balconies. Each entry door has art glass windows, and the interiors have wood trim, window seats, and built-in cupboards. An exterior pergola joins the two sides of the Linwood apartments. (AGS.)

With two apartments on each of the three floors, the Whitehall apartments are smaller than Scheibler's Old Heidelberg apartments, built in 1905 on Braddock Avenue. However, all three apartment buildings have an art glass flower in their front doors, as well as window seats, built-in china cabinets, and fireplaces in the living and dining rooms. In *The Progressive Architecture of Frederick G. Scheibler Jr.*, Martin Aurand states, "Special emphasis was laid on plantings and the provision of pleasant views and sunlight," as was the case with many of Scheibler's structures. (AGS.)

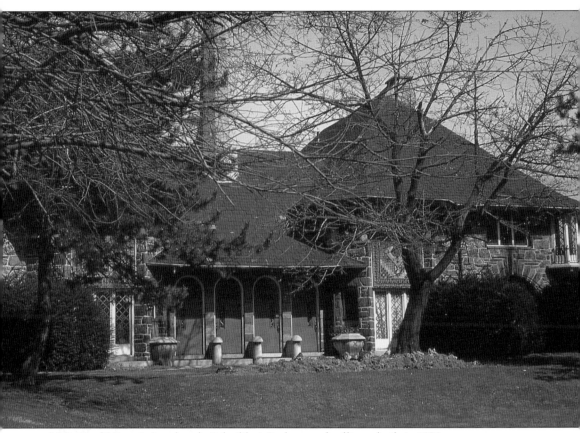

A National Historic Landmark, Scheibler's Parkstone dwellings, built in 1922, are a testament to his imagination. Located at 6937–6943 Penn Avenue, four side-by-side front entries, ornamented with whimsical toadstools and stained-glass intertwining roses, make these homes dwellings instead of apartments. In his book *The Progressive Architecture of Frederick G. Scheibler Jr.*, Martin Aurand writes that the front entries are "private beyond the first stoop." Aurand compares the roof's multiple delicate folds to origami. As further proof to Scheibler's whimsy, a fully sculpted seagull perches on the southeast corner of the facade, and inside, a large fireplace with interior mosaics depicting panthers and kingfishers accents the living room of one of the four dwellings. A photographic detail of the mosaic appears in Aurand's book. (AGS.)

In another excerpt from *The Progressive Architecture of Frederick G. Scheibler Jr.*, Martin Aurand further describes Scheibler's unique style: "But Scheibler's ornament was unlike that of his contemporaries, for he used simple art glass and tilework—which often featured naturalistic motifs like flowers and birds—to accent plain stucco or brick walls. His trademark, the exposed I-beam lintel over windows, doors, and porches, was a frank and highly unusual use of a modern structural material in the role of a traditional building element." (AGS.)

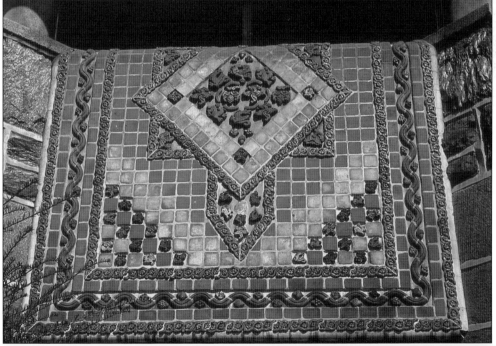

The "Oriental rugs" that drape over from the second-story balconies are actually mosaic tiles that were supposedly arranged and assembled by Scheibler himself. Harry Rubins and his sister Rose, who commissioned the home, reportedly requested the so-called rugs; however, they would lose the home at a sheriff's sale 10 years after Parkstone was built. Scheibler's architectural work embodied nearly 150 commissions over five decades in early-20th-century Pittsburgh neighborhoods and suburbs. (AGS.)

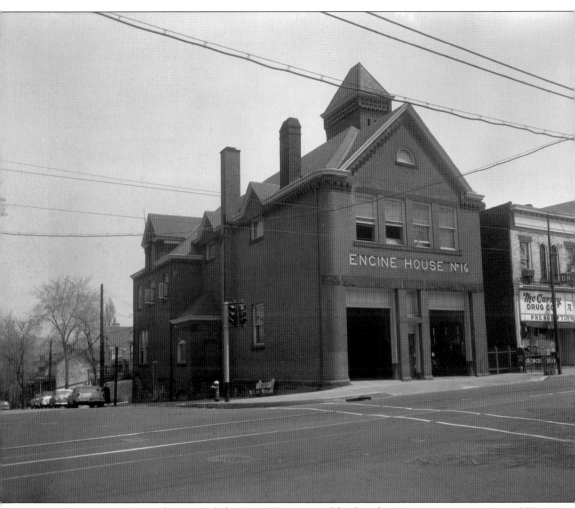

Engine House No. 16 has served the Point Breeze neighborhood since its construction in 1890. Around 1912, a short circuit electrocuted all the horses in their stalls at the firehouse. Shortly thereafter, No. 16 was motorized on September 14, 1912. It was not known if the two events were related, but 75 percent of all Pittsburgh firehouses had been motorized by 1921. Outwardly, Engine House No.16 remains the same—with the exception of its color. Shortly after this photograph was taken in April 1962, the building was painted a bright red. Neighbors complained, and the building was repainted "brick pink." The interior has changed, shifting from horses to fire engines, with the removal of horse stalls, as well as the feed room and hayloft. In 2010, the City of Pittsburgh put the building on the market, which attracted substantial interest. Mary Allison grew up in Point Breeze, and her father owned Brown's Drugstore next to the engine house. Living in Point Breeze, she recalled, was like living in the country: "There was always a tree to climb or a swing to hang." (ASC.)

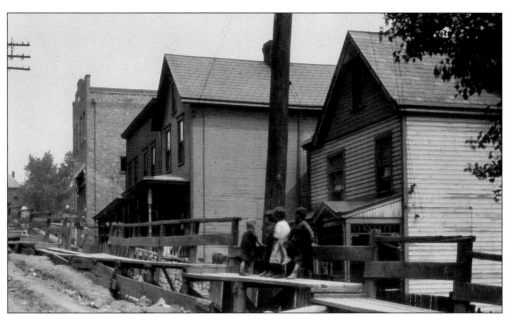

Ralph B. "Lefty" Mellix pitched in over 1,500 games, in which he tossed nine no-hitters and six one-hitters. Once, Mellix struck out 13 men in a row without a single ball being called. He is quoted as saying: "I never knew where I was gunna play next. I played for every team in the area, the Homewood Grays, the Pittsburgh Crawfords, 18th Ward, the (Youngstown) Brown Stars; I even played for a Cuban team under the name of Mellico." (Courtesy of David and Marlene Demarest.)

One newspaper article written about Mellix noted that, for 25 years, he never won less than 25 games and never lost more than 12. In addition to being elected into the Western Pennsylvania Hall of Fame, Mellix, who died in March 1985, would also be honored at the National Baseball Hall of Fame in Cooperstown, New York, where his personal photographs and articles are displayed. This 1937 scene of Westinghouse Park was taken near the baseball player's home in North Point Breeze. (ASC.)

Tired of seeing public services diminish in their neighborhood, Gladys McCullough and her friend Blanche David founded the Westinghouse Park Club in North Point Breeze. McCullough and her family originally moved to North Point Breeze because, in her words, "It was a nice, clean community, and we liked it." She and David organized the Westinghouse Park Club with their fellow Westinghouse Park neighbors to keep North Point Breeze a family/residential community. The club has actively opposed the infiltration of group homes. "We knew about them from the beginning," McCullough said of the 7200 block of Thomas Boulevard, where a shelter for battered women had tried to locate. "They were at our end of the neighborhood; we were against their moving in, and we told them so." A musician herself, McCullough spearheaded many of the musical recitals and concerts for the neighborhood. She introduced residents to the Denmon Brothers, noted siblings who performed classical pieces for cello and violin. Her concert locations ranged from Westinghouse Park to many of the North Point Breeze residential homes. (NPBPDC.)

Maida Springer Kemp and Dr. Anna Pauline "Pauli" Murray, childhood friends from Brooklyn, New York, shared a home on Thomas Boulevard until Murray's death in 1985. Murray was a lawyer, educator, civil war activist, and author, as well as the first black woman to be ordained as an Episcopalian priest. After the completion of her book *Songs in a Weary Throat*, Murray went on to write a second book, an autobiography dedicated to Kemp, in which she describes teaching at Brandeis, looking for her roots in Ghana, befriending Eleanor Roosevelt, helping to found NOW (the National Organization for Women) in the 1960s, and working in the law profession. Described by Murray as an "incomparable companion, critic and guide on the pilgrimage," Kemp was a lifelong labor activist in the United States and abroad. Previously married, Kemp was survived by her son, who lives in Pittsburgh, at the time of her death in 2005. This image of Thomas Boulevard was taken near the childhood friends' home. (NPBPDC.)

Bill Grisom is a "fixture in the community," according to North Point Breeze resident and author Albert French. "He is harder on this community and has fought hard and passionately for this area." From his days at the *Post-Gazette*, French remembers how Grisom fought against the establishment of group homes in the neighborhood. A longtime resident of the neighborhood, Grisom is passionate about North Point Breeze, having battled for group home legislation, better police relations, placement of street cleaning signs, and boulevard island reconstruction, among other community activities. In addition to serving as a 14th Ward committeeman, Grisom founded the Good Neighbor Club, a resident group concerned with the betterment and preservation of North Point Breeze as a family-related community. Fellow North Point Breeze residents echo the sentiment that he remain passionate about the area for many years to come. (NPBPDC.)

Noted harpsichordist Ralph Hill entertained North Point Breeze residents with many concerts. This photograph was taken during his performance at a local resident's wedding. Dr. Hill grew up in the Hill District, where he was self-taught on the piano. In his youth, he could play Stephen Foster songs without requiring sheet music, a talent that continued into adulthood. In the *Pittsburgh Post-Gazette* of March 24, 2007, Gary Rotstein speaks to Hill's profound impact: "The students, peers and music lovers whom Dr. Hill either educated or entertained locally in his upbeat manner since the 1960s would easily tally in the thousands." Dr. Hill performed for many years at the Le Mont restaurant, where people would go out of their way to see and hear him play. With a PhD in education, Dr. Hill also taught music in city schools, in addition to private music lessons, and led bands, choirs, and other vocal groups. "He was a strong disciplinarian, but you couldn't ask for anybody who had more love for people," said Dr. James Alston, curriculum supervisor of music for Pittsburgh Public Schools. Dr. Hill passed away in 2007. (DMD.)

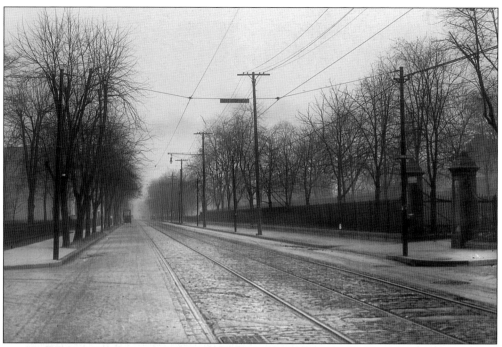

As the fortunes of affluent families swelled, it became necessary for them to move away from Pittsburgh, and when wealthy patriarchs died, their surviving family members did not want to stay to maintain the family homes. The North Point Breeze neighborhood began to deteriorate with the absence of the owners of these palatial mansion. Over time, the vacant housing became problematic, and city officials were forced to introduce group housing to North Point Breeze. (AGS.)

Bill Grisom and Marlene Demarest, shown here, organized many North Point Breeze residents to defend their neighborhood against the infiltration of group housing. Grisom and Demarest, as well as other noted North Point Breeze residents, have always fought to preserve the integrity of their familial neighborhood. (NPBPDC.)

North Point Breeze resident Albert French has worn many hats. An author, *Pittsburgh Post-Gazette* photographer, and Vietnam veteran, French has also held offices in neighborhood organizations, such as head of public relations and vice president for the North Point Breeze Coalition. French's pride in the neighborhood is reflected in his following statements: "I developed an understanding of the neighborhood's problems. Internally the neighborhood was a good one. It had always been a strong self-maintaining community that I admired when I rode through on my bike as a kid. The problems that the community faces are essentially those imposed on us by others who don't live here, but insist on defining NPB [North Point Breeze] according to their own inaccurate perceptions. . . . I want to see NPB continue to be a good community to live in. Like any homeowner, I'm interested in protecting my investment and interests here, which are substantial." (NPBPDC.)

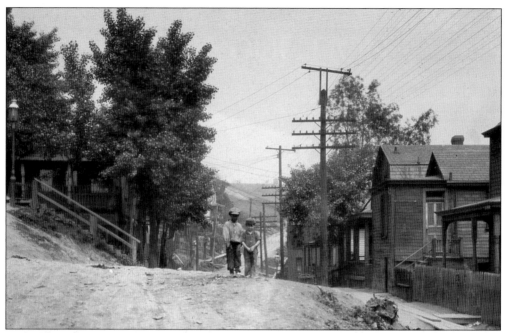

The success of Albert French's first novel *Billy*, among others, prompted the elite Royal Book Club in London to approach him in regard to writing a foreword for the reprint of Harper Lee's *To Kill a Mockingbird*. Lee was notorious for never allowing a foreword in any of her books, but she was so taken with French's that it was the first one she ever authorized. (AGS.)

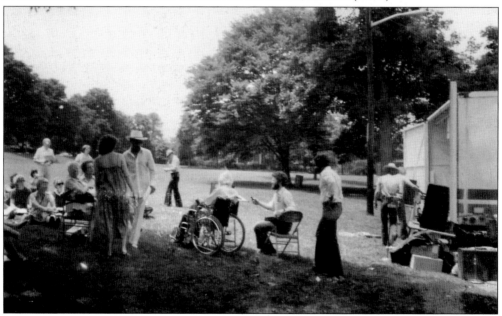

Seen among the crowd in this Westinghouse Park image, French reflects on a statement pertaining to himself: "One of the journalists in London once said something that I felt very good about, though. I believe it was the lead for his story about me. He said: 'Pittsburgh is known for its writers: August Wilson, John Wideman and now Albert French.' And the guy didn't even know that John was my cousin." (NPBPDC.)

As a young boy growing up on Finance Street (north of the railroad tracks and North Point Breeze), French remembers seeing a tall white girl with reddish-blond hair periodically walking around the area of Braddock and Penn Avenues. He would often see her sitting by a billboard sign near the intersection. In later years, French mused whether she had been fellow Point Breeze author Annie Dillard. (AGS.)

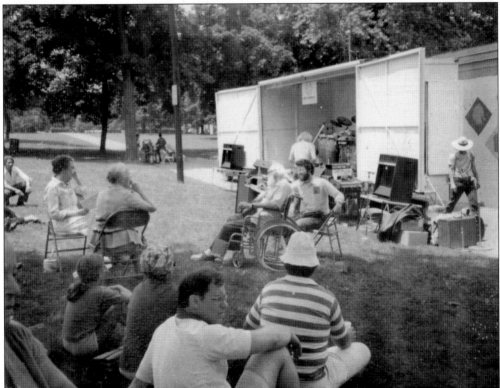

French has lived in North Point Breeze since the mid-1970s. As noted, French and John Edgar Wideman—author of *Hoop Roots*, *Sent for You Yesterday* (a PEN/Faulkner Award winner), and *Philadelphia Fire* (a second PEN/Faulkner Award winner), among others—are cousins. Many of Wideman's novels are set in Homewood, with *Hoop Roots* set around Westinghouse Park. The second African American to be awarded a Rhodes Scholarship, Wideman is a professor of Africana Studies at Brown University. (NPBPDC.)

Beloved Pittsburgh mayor Richard S. Caliguiri (left) and North Point Breeze neighborhood champion Bill Grisom are featured in this photograph of Westinghouse Park. Grisom has been a stalwart advocate of North Point Breeze, and his relationship with many Pittsburgh politicians has helped to keep the neighborhood stable and safe for residents and their families. Caliguiri served as mayor of Pittsburgh from 1977 to his death in 1988. Sadly, Caliguiri was diagnosed with amyloidosis in the late 1980s. According to the Mayo Clinic, amyloidosis is a disease that occurs when substances called amyloid proteins build up in a person's organs. Amyloid is an abnormal protein usually produced by cells in bone marrow that can be deposited in any tissue or organ. Within a few years of Caliguiri's death, Louis Tullio, longtime mayor of Erie, Pennsylvania, and Robert Casey, Pennsylvania governor, were afflicted with the usually fatal disease. (NPBPDC.)

Photographed in Westinghouse Park, Mayor Caliguiri (left) is pictured speaking to concerned longtime residents of North Point Breeze. He attended the concert on the invitation of neighborhood defender and leader Bill Grisom. The Caliguiri family, including (from left to right) wife Jeanne and their sons David and Gregg, are shown listening intently. Local law enforcement officers were also in attendance, as well as other citizens from the neighborhood. (NPBPDC.)

Speaking with local policemen, Caliguiri (center) has an audience including some of the many diverse residents of North Point Breeze. Bill Grisom (second from right) is seen behind the mayor. Many of John Edgar Wideman's novels are set in Westinghouse Park. The author grew up in Pittsburgh and graduated from Peabody High School. Although Wideman never lived in Point Breeze, his cousin Albert French remains a North Point Breeze resident. (NPBPDC.)

North Point Breeze Planning and Development Corporation member Cheryl Hall is seen on a ladder descending into one of the George Westinghouse estate tunnels. In 2006, the tunnels were reopened during an excavation of the site. Several members of the Planning and Development Corporation were in attendance, as were Westinghouse's great-grandson, George Westinghouse IV; Christine Davis, archaeologist; and Edward J. Reis, executive director of the George Westinghouse Museum in Wilmerding, Pennsylvania. (NPBPDC.)

In a mutual agreement between the Engineers' Society and the North Point Breeze group, it was agreed that the City of Pittsburgh would maintain Westinghouse Park. North Point Breeze residents and other residents of the city would benefit from the park, and the Society of Engineers would oversee it for future legalities and the like. This North Point Breeze event in Westinghouse Park concludes with a musical performance enjoyed by all ages of diverse neighborhood residents. (NPBPDC.)

Seven

BAKERY SQUARE AND THE 21ST CENTURY

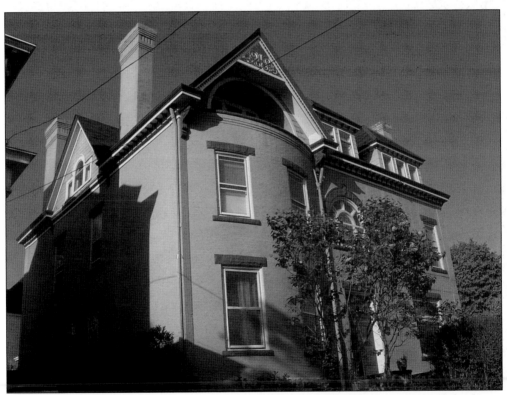

Charles Henry Allen Sr., who founded the Allen Gauge and Tool Company, owned this house at the turn of the last century. Allen made significant contributions as producer and inventor of mechanical instruments and devices. At 11 years old, he learned the trade of watchmaking from some of the brightest minds in the field of expert and scientific mechanics at the foremost factories in the world. (SLL.)

A horse link on the curb in front of the Charles Allen house remains from the 1900s. Links like these were used to tie up the reins of carriages and individual horses. During World War II, Allen's company was a key firm in the designing and supervision of special tools and gauges used in the manufacturing of vital war equipment. Allen also demonstrated his dexterity, skill, patience, and genius by engraving the entire alphabet, numbers one through nine, his own initials, and the date on the head of a pin. Allen then drilled a hole through the body of the pin. (SLL.)

This detailed image of the entryway at 201 East End Avenue illustrates Frederick Scheilber's progressive architectural aesthetics, which are still evident today. This Whitehall apartment door welcomes visitors and residents alike with its graceful folds above the triangular-shaped casement window. The ornamental wrought-iron grill functions to both protect and beautify the door. (AGS.)

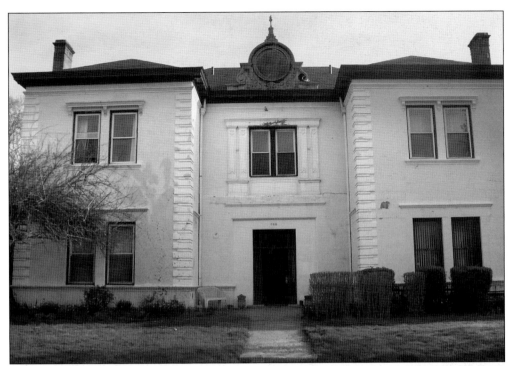

An interesting example of adaptive reuse is the apartment building on Meade Place, which originally served as the garage and stable for the H.J. Heinz estate. It garaged the first car in Pittsburgh—an 1898 Panhard et Levassor Tonneau from Paris, France, owned by H.J. Heinz. The vaguely Châteauesque-style building housed the horses and stablemen, then automobiles and garage personnel. (SLL.)

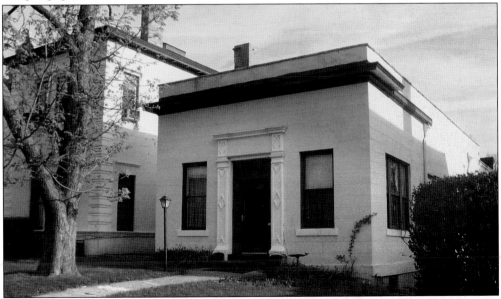

H.J. Heinz used the smaller building on the right as a personal museum for his artifact collection, which he eventually would open to the public. His artifacts included an extensive rare watch collection that was bestowed to the Carnegie Museum of Art. (SLL.)

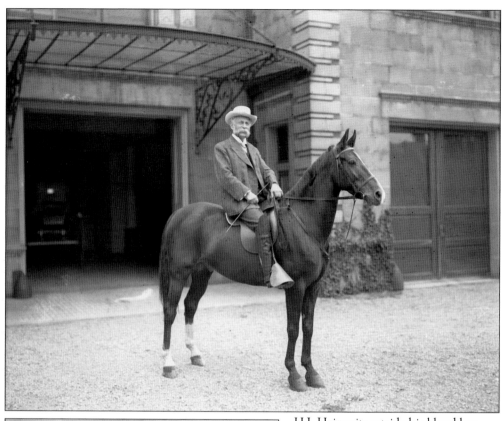

H.J. Heinz sits astride his blood bay mare in front of the stable and garage. (Heinz and his son Clifford are seen in an open carriage on page 27) Over 100 years later, the wrought-iron awning is gone, and the stable/garage doors have been replaced with window frames, but the overall building still stands in North Point Breeze. (HHC.)

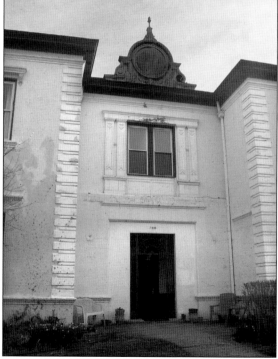

This image shows the stable and garage as seen today. Both have been converted into an apartment building. Where Heinz's horse-drawn carriage was garaged in the previous image is now the entryway for the apartment building, and what was once the driveway in front of the garage and stable is now Meade Place. (SLL.)

Used as the estate superintendent's house, this large residence on North Lang Avenue remains in existence from the H.J. Heinz estate. The original estate walls can still be seen in the 7000 block of Penn Avenue and the 100 block of North Lang Avenue. (SLL.)

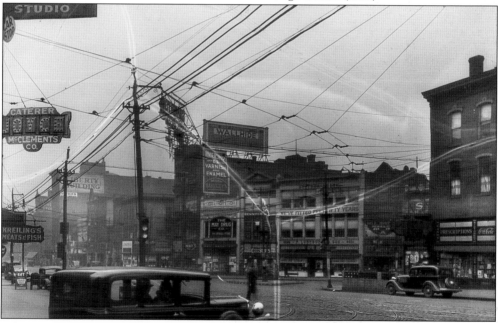

Taken on February 10, 1935, this street scene of Penn Avenue and Frankstown Road from Shady Avenue captures the marquees of a studio, the Joyce McClements Company (caterer), and the Kreiling's Meats & Fish store, all on the left side. The Liberty Building sign, among others, is visible in the background, behind the electric and trolley car lines intertwining overhead. A "Car Stop" sign is also seen directly below the "Studio" sign at left. (AGS.)

An excavation in Westinghouse Park took place in October 2006 to verify and explore the tunnels that exist under the 10-acre former estate of George Westinghouse. North Point Breeze Planning and Development Corporation member Cheryl Hall and other local residents joined George Westinghouse IV, Christine Davis, and Edward J. Reis for the dig. Among the 1,249 unearthed artifacts were fragments of granite and marble, a Haviland porcelain saucer, and a crystal perfume bottle. After the deaths of George Westinghouse and his wife, Marguerite, in 1914, their son George and his wife, Violet, sold the Point Breeze property. As new owners, the Engineers Society of Western Pennsylvania planned to create a city park and erect a memorial to Westinghouse, which was established in Schenley Park. In a 1918 city ordinance accepting the estate, Solitude was to be moved in six months; however, the mansion was demolished in 1919, and a portion of the home collapsed into the basement. (NPBPDC.)

In a May 2006 *Pittsburgh Post-Gazette* article, "Vanished Westinghouse Estate Here Yields Some Secrets," architectural critic Patricia Lowry interviews several North Point Breeze residents. This image of another excavation site fueled their hopes to "see gas lighting in the park and a new shelter reminiscent of the stable . . . If and when that happens, they to involve neighborhood schoolchildren in the search for what remains of the home and workshop of Pittsburgh's greatest inventor." (NPBPDC.)

Archaeologist Christine Davis's findings also note "several architectural features including stone steps leading from Lang Avenue to North Murtland Street, stone entrance pillars, carriage drives and 45 hardwood and specimen trees, notably pin oaks planted in clusters of three." The Davis report identifies six other species: horse chestnuts, Norway maples, gingkoes, sawtooth oaks, a Siberian elm, and an Amur cork. (NPBPDC.)

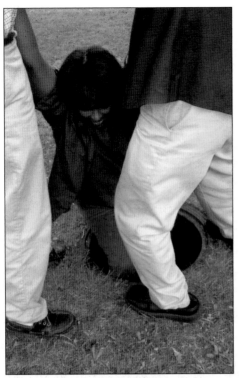

George Westinghouse IV and a North Point Breeze resident assist Cheryl Hall of the North Point Breeze Planning and Development Corporation as she is lowered into the one of the entrances to the tunnels of the former George Westinghouse estate. (NPBPDC.)

This Queen Anne house with large turret is the last remaining structure associated with the Boulevard Park Plan of the late 1890s. Situated in the oldest part of North Point Breeze, the Boulevard Park Plan encompassed the neighborhood west of North Dallas Avenue to Fifth Avenue. McPherson and Thomas Boulevards and Mead(s) Street were the main thoroughfares of the Boulevard Park Plans. (SLL.)

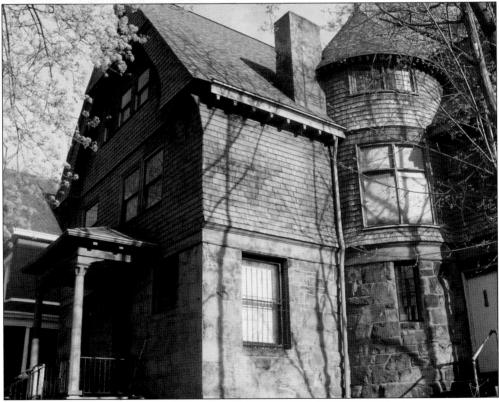

Harry Thaw was tried twice for the murder of architect Stanford White in the "Murder of the Century." Eventually, Thaw was incarcerated to a New York asylum, enjoying nearly complete freedom. In 1913, he walked out of the asylum and was driven over the border to Canada. When he was extradited back to the United States in 1915, a jury judged him sane, and he was released. Thaw and his wife, Evelyn Nesbit, were divorced in the same year. Thaw died of a heart attack in Florida at the age of 76. In his will, he left $10,000, less than one percent of his fortune, to former wife Evelyn Nesbit. He is buried in Allegheny Cemetery in Pittsburgh. *The Girl in the Red Velvet Swing* was released in movie theaters in 1955. The 1975 historical novel *Ragtime*, by E.L. Doctorow, was adapted into a film and musical of the same name. This brick wall is what remains of the Lyndhurst estate. (SLL.)

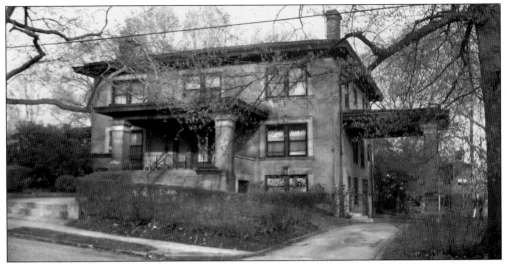

Only two buildings from the George Westinghouse estate still exist today. Westinghouse built two Italianate-style homes: one for his son near the corner of North Murtland Street and Penn Avenue and the other for his private physician. Solitude, the Pittsburgh residence of George Westinghouse and his wife, Marguerite Erskine Walker Westinghouse, was ultimately razed. The City of Pittsburgh owns the property, which was turned into a city park now known as Westinghouse Park. (SLL.)

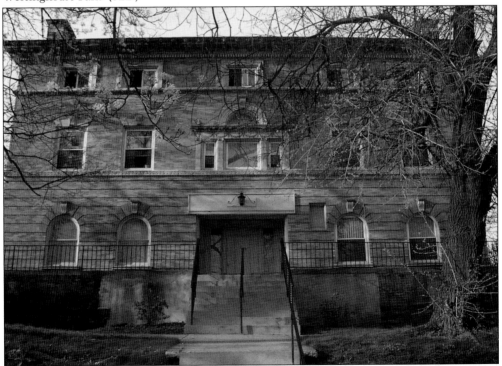

In addition to building a home for his son George III, George Westinghouse also built another Italianate-style house for his physician. The building has been through several transformations since it was a private home. Located on the corner of Thomas Boulevard and North Lang Street, the structure still stands today as an apartment building. (SLL.)

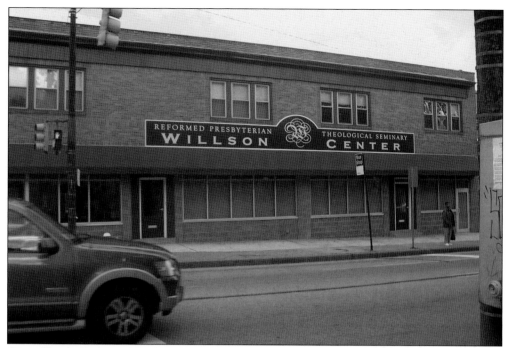

Owned by the Reformed Presbyterian Theological Seminary across the street, the Willson Center occupies the site of the former George Lauder home. Consequently, the seminary resides in the Gables, the former home of Durbin Horne of the Joseph Horne Company. (See pages 30 and 38.) (SLL.)

Located on Baum Boulevard near Penn Avenue in East Liberty, this razed lot is characteristic of the attitude surrounding buildings in Pittsburgh in the 1930s. In most cases, if the building did not serve a purpose or was too costly to maintain, it was less expensive to demolish it. (AGS.)

Businesses and people were not the only sights on Penn Avenue. These chickens, bound for local meat markets, are seen in crates on May 10, 1935. (AGS.)

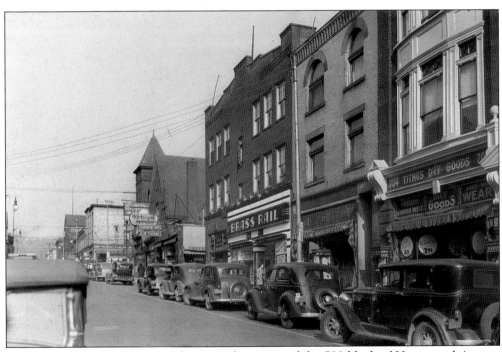

Another center of commerce is shown in this image of the 700 block of Homewood Avenue on November 10, 1937. In addition to a dry goods store on the right, the Brass Rail and other businesses, bars, and restaurants line the street. (AGS.)

A small child is photographed in front of his house on the corner of Braddock Avenue and Susquehanna Street on October 16, 1913. Road paving has not begun on these edges of the Point Breeze neighborhood. (AGS.)

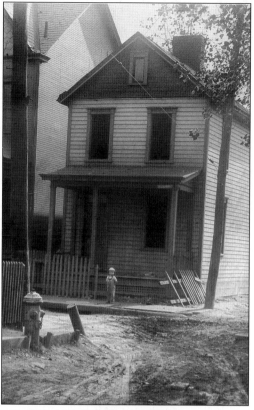

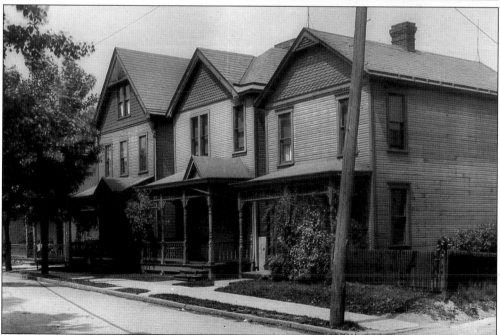

These modest homes on Braddock Avenue were photographed on June 12, 1913, as part of the city's inventory collection. (AGS.)

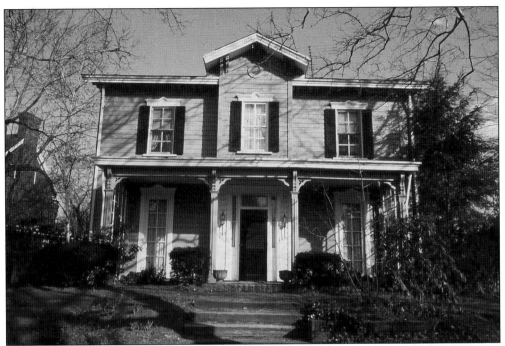

Seen in this image from the Arthur G. Smith Collection at Chatham University, this home at 319 South Lexington Street is one of the oldest in the Point Breeze neighborhood that still exists today. The Frick Art and Historical Center as well as the Clayton mansion are in the next block. (AGS.)

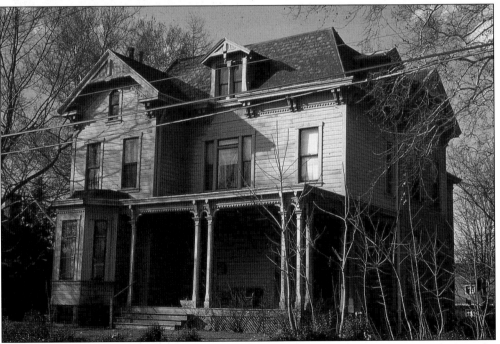

This home, located at 205 South Homewood Avenue, is another photographic example from the Arthur G. Smith Collection. However, the house does not exist anymore, and the Roycrest Place cul-de-sac takes its place. H.C. Frick's first house, Clayton, is across the street. (AGS.)

This detailed image of a residence on Briarcliff Road marks another example of early homes that still exist within the boundaries of the Point Breeze neighborhood. Taken in March 1983, this image is part of the Arthur G. Smith Collection at Chatham University. (AGS.)

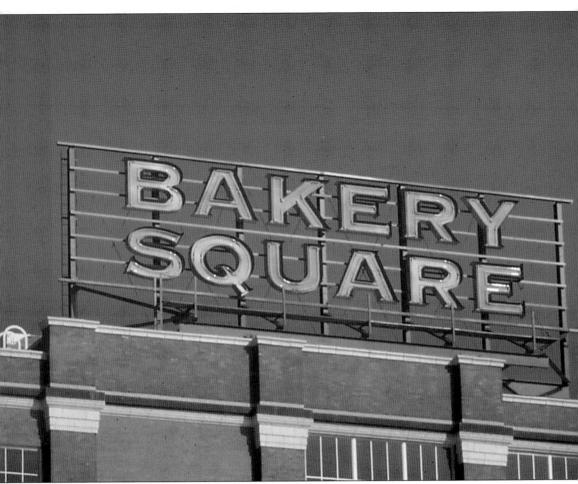

Steps from the old location of the Point Breeze Hotel, a 21st-century chapter is beginning in the form of Bakery Square. The hallmark of this retail and office space includes the old National Biscuit Company (later Nabisco) location. For decades, the company permeated the air with the scent of baking Lorna Doones, as noted in Annie Dillard's *An American Childhood*: "Behind it, Pittsburgh's Nabisco plant . . . issued the smell of shortbread today; they were baking Lorna Doones. . . . The heavy, edible scent of shortbread maddened me in my seat." Annie begins to dream of throwing her Ellis School teachers into the Lorna Doone batter. (SLL.)

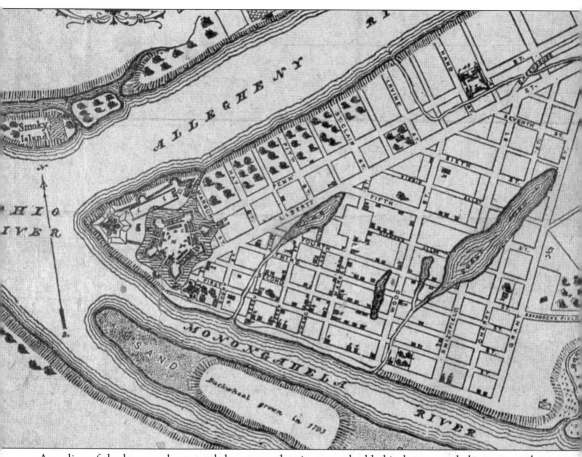

A replica of the bronze plaque and the stump that it was embedded in has recently been erected in the park on the corner of Fifth and Penn Avenues on the grounds of the Point Breeze Hotel. This 1750s map depicts Fort Duquesne and General Braddock's field road. The original plaque and its replica commemorate Brig. Gen. John Forbes's march on Fort Duquesne. (SLL.)

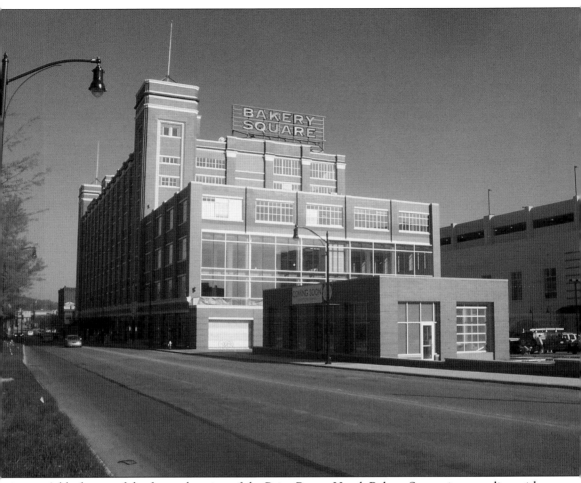

A block west of the former location of the Point Breeze Hotel, Bakery Square is expanding with real estate space on the former grounds of the Reizenstein School. The new buildings are located to the south, across the street from the view in this image. Annie Dillard writes: "Millionaires' encrusted mansions, now obsolete and turned into parks or art centers, weighed on every block. They lent their expansive, hushed moods to the Point Breeze neighborhoods where we children lived and where those fabulous men had lived also, or rather had visited at night in order to sleep. Everywhere I looked, it was the Valley of the Kings, their dynasty just ended, and their monuments intact but already out of fashion." (SLL.)

BIBLIOGRAPHY

Alberts, Robert C. *The Good Provider: H.J. Heinz and His 57 Varieties*. Boston: Houghton Mifflin Company, 1973.

Aurand, Martin. *The Progressive Architecture of Frederick G. Scheibler, Jr.* Pittsburgh: University of Pittsburgh Press, 1994.

Carlson, W. Bernard. *Tesla: Inventor of the Electrical Age*. Princeton, NJ: Princeton University Press, 2013.

Dillard, Annie. *An American Childhood*. New York: Harper & Row, 1987.

Fleming, Hartley G. *The East End: 1898–1915*.

Johnston, William G. *Life and Reminiscences from Birth to Manhood of William Graham Johnston*. Pittsburgh [New York, Knickerbocker Press], 1901.

Jonnes, Jill. *Empires of Light: Edison, Tesla, Westinghouse, and the Race to Electrify the World*. New York: Random House, 2003.

Kidney, Walter C. *Pittsburgh: Then and Now*. San Diego: Thunder Bay Press, 2004.

Lowry, Patricia. "Vanished Westinghouse Estate Here Yields Some Secrets." *Pittsburgh Post-Gazette*, May 2, 2006.

Phleps, H.W. "The Old Wilkins Homestead." *Pittsburgh Index*, May 16, 1903.

Ruck, Rob. *Sandlot Seasons: Sport in Black Pittsburgh*. Urbana: University of Illinois Press, 1987.

Smith, Arthur G. *Pittsburgh: Then and Now*. Pittsburgh: University of Pittsburgh Press, 1990.

Toker, Franklin. *Pittsburgh: An Urban Portrait*. Pittsburgh: University of Pittsburgh Press, 1986.

PITTSBURGH, PENNSYLVANIA

Named for the famous early-19th-century Point Breeze Hotel that stood at the corner of what is now Fifth and Penn Avenues, Point Breeze has been home to some of the wealthiest families in Pittsburgh and the country. Moguls such as Carnegie, Westinghouse, Frick, Mellon, and Thaw all resided in Point Breeze, thus christened "Pittsburgh's Most Opulent Neighborhood." H.J. Heinz owned the first car in Pittsburgh, which was garaged at his estate in North Point Breeze, and present-day Wilkins Avenue was originally the private road to the 650-acre estate of senator, ambassador to Russia, and judge William Wilkins. However, many of these prestigious estates were later razed and divided to become smaller residential lots, driving the real estate market to create more homes to accommodate 20th-century families. In later years, the Point Breeze neighborhood became the home of several well-known authors, including Annie Dillard, Albert French, and David McCullough, as well as professional athletes Willie Stargell of the Pirates and L.C. Greenwood of the Steelers and everyone's favorite neighbor, Mr. Rogers.

Sarah L. Law has been a Point Breeze resident for over a decade. A member of the Frick Art & Historical Center and an alumna of Carnegie Mellon University, she is indebted to the vast archival collections, personal interviews, and cherished individual photographs used to compile this heartfelt snapshot of Pittsburgh's Point Breeze. Pittsburgh mayor Bill Peduto has also graciously contributed a foreword to the book.

The Images of America series celebrates the history of neighborhoods, towns, and cities across the country. Using archival photographs, each title presents the distinctive stories from the past that shape the character of the community today. Arcadia is proud to play a part in the preservation of local heritage, making history available to all.

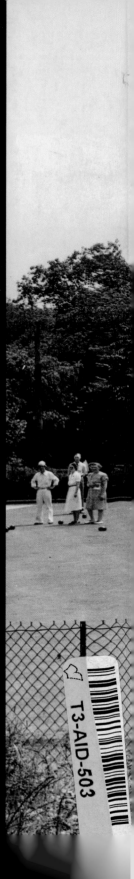

ARCADIA
PUBLISHING

www.arcadiapublishing.com

ISBN-13 978-1-4671-2233-7 $21.99
ISBN-10 1-4671-2233-5

52199

MADE IN THE USA